The Art Institute of Chicago Museum Studies

VOLUME 11, NO. 2 (SPRING 1985)

The Art Institute of Chicago Museum Studies

VOLUME 11, NO. 2 (SPRING 1985)

© 1985 by The Art Institute of Chicago
ISSN 0069-3235

Published by The Art Institute of Chicago, Michigan Avenue at Adams Street, Chicago, IL 60603. Distributed by The University of Chicago Press, Journals Division, P.O. Box 37005, Chicago, IL 60637. Regular subscription rates: $12 for members of the Art Institute, $16 for other individuals, and $25 for institutions. All back volumes are available from The Art Institute of Chicago, Museum Store, and The University of Chicago Press at $7 per volume.

Editor of *Museum Studies*: Susan F. Rossen; Assistant Editor: Elizabeth A. Pratt; Designer: Betty Binns Graphics, New York

Cover: Josef Hoffmann (Austrian, 1870–1956), and Carl Otto Czeschka (Austrian, 1878–1960), designers; Wiener Werkstätte, manufacturer, *Tall Case Clock*, c. 1906 (detail of Figure 1, p. 84). Photo: William Frederking, Chicago.

9,000 copies of Volume 11, no. 2 were typeset in Stempel Garamond by Trufont Typographers, Hicksville, NY, and printed on 70 lb. Frostbrite Matte by American Printers and Lithographers, Chicago.

The Art Institute of Chicago Museum Studies is published through the generosity of the Sterling Morton Charitable Trust.

Preface

The spring 1985 issue of The Art Institute of Chicago's recently revised journal, *Museum Studies*, continues the survey of the museum's extensive and important holdings begun in the fall 1984 issue. Increasingly in recent years, our understanding of works of art has been expanded by consideration of larger contexts—geographic and economic, social and political, intellectual and religious. In her article on a tall case clock designed in 1906 by two Viennese artists, Josef Hoffmann and Carl Otto Czeschka, the Art Institute's Eloise W. Martin Curator of Decorative Arts, Lynn Springer Roberts, evokes a period of high idealism and intense aesthetic experimentation in turn-of-the-century Vienna. That city's artistic community, like many others throughout Europe, was consciously seeking at the time to create a new design aesthetic to suit the new century. The museum's recently acquired clock was innovative in several ways. It was the result of an artistic collaboration between an architect and a designer. It was a product of the Wiener Werkstätte, a cooperative workshop where artists combined their varied skills to create total environments for the modern age. Simple in outline and sumptuous in detail, it is a paramount example of craft evolved into high art, in the spirit of William Morris, influential leader of the English Arts and Crafts Movement, who encouraged the elimination of hierarchies between the fine and decorative arts.

Between 200 B.C. and A.D. 500, the Nazca peoples of ancient Peru evolved sophisticated firing techniques and an impressive range of colors with which to decorate ritual ceramic pots with a profusion of plant, animal, and human motifs. As Richard F. Townsend, the museum's Curator of Africa, Oceania, and the Americas, demonstrates in an analysis of a group of Nazca ceramics in the Art Institute, these motifs constitute the visual texts of a people without written language. Such works can be seen as reflective of the daily concerns and life of this ancient people as well as symbolic of the values of their culture, the organization of their society, and their belief that all aspects of human life are part of a larger, cosmic system.

Like the Nazca ceramics, the *Panoramic View from the Sasso near Rome*, a drawing by the great French artist Claude Lorrain, is a very small-scale work that succeeds in expressing a sense of the infinite. When the late Harold Joachim, Curator of Prints and Drawings, purchased this sheet in 1981, he asked the leading expert on Claude, Swiss scholar Marcel Roethlisberger, to write about it. Calling the Art Institute drawing one of the "the most outstanding sheets of Claude's 1,300 or so extant drawings," Professor Roethlisberger relates its fascinating history, analyzes the artist's several approaches to landscape drawing, and demonstrates the critical position the drawing occupied in the evolving vision of one of Europe's greatest landscape painters. He also situates the drawing in a survey of panoramic views from the 16th to the 19th centuries, an overview broadly conceived and boldly realized in the spirit of the Art Institute drawing itself.

Recently, one of the Art Institute's greatest 17th-century paintings, *Cupid Chastised* by Bartolomeo Manfredi, was featured in the Metropolitan Museum of Art's exhibition, "The Age of Caravaggio." Alfred Moir, Professor of Art History at the University of California at Santa Barbara and a leading American specialist on Caravaggio and his followers, has discovered several documents in the Vatican archives that have permitted him not only to firmly establish the authorship of the museum's painting as by Manfredi, but also to reconstruct his influential but brief career. *Cupid Chastised*, with its elegant staging and striking palette, is an accomplished, early work that reveals Caravaggio's impact on Manfredi. How Manfredi came to grips with Caravaggio's revolutionary style and approach to subject matter—a struggle he shared with many of his contemporaries—and how he established his own individuality is the major focus of this article.

Certain contemporary artists have come to feel the need to define the role played by context in the creation, exhibition, and ownership of art. For the past 20 years, French conceptual artist Daniel Buren has provided pointed, and often witty, commentary on our ideas about art in works that cannot be considered separately from their physical and cultural context. In 1977, using his characteristic striped materials, Buren created a striking sculpture, *Up and Down, In and Out, Step by Step*, for the Art Institute's Grand Staircase and Michigan Avenue stairs. Buren's intention was to sensitize the viewer both to the museum's actual physical setting and to the complex meanings of the expressions referred to in the piece's title. Former Art Institute curator Anne Rorimer, now an independent scholar and writer living in Chicago, examines this work in relationship to Buren's developing ideas since the late 1960s and demonstrates its correspondence with the artistic goals of other key American and European artists of the period who are represented in the Art Institute's collection.

Professor Roethlisberger's article can serve as a kind of announcement of the next issue of *Museum Studies*, a very special one dedicated to the memory of Harold Joachim, Curator of Prints and Drawings from 1959 to 1983. Joining in this tribute are several of Dr. Joachim's eminent colleagues and protégés: included will be an appreciation of Dr. Joachim by Egbert Havercamp-Begemann of New York University and articles by Suzanne Folds McCullagh of the Art Institute and Pierre Rosenberg of the Musée du Louvre on Chardin; Evan Maurer, formerly of the Art Institute and now director of the Art Museum of the University of Michigan, on Joan Miró; Diane de Grazia of the National Gallery, Washington, on Barocci; and Larry Silver of Northwestern University on a print of Emperor Maximilian I. We know that the museum's and Dr. Joachim's many friends will look forward to this issue, which focuses entirely on the collection that this outstanding curator was so instrumental in forming.

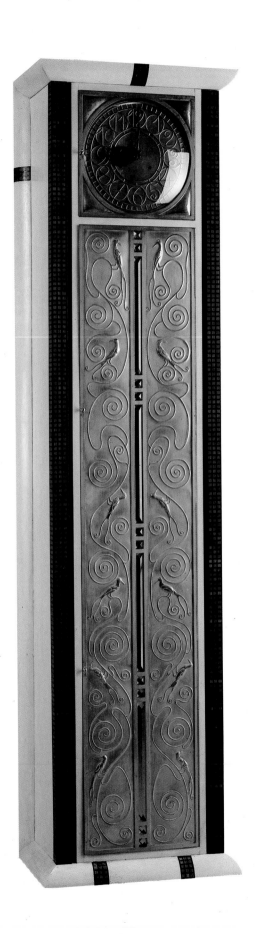

A Wiener Werkstätte Collaboration

LYNN SPRINGER ROBERTS
*Eloise W. Martin Curator of European
Decorative Arts*

FIGURE 1 Josef Hoffmann (Austrian,
1870-1956), and Carl Otto Czeschka, Aus-
trian (1878-1960), designers; Wiener Werk-
stätte, manufacturer. *Tall Case Clock*, c. 1906.
Painted wood with ebony and mahogany
inlays; gilt brass, glass, cut glass, silver-plated
copper (hands); clock works;
179.5 × 46.5 × 30.5 cm. The Art Institute of
Chicago, Laura Matthews Fund, Mary Waller
Langhorne Fund (1983.37). Photo: William
Frederking, Chicago.

A STUNNING addition to the Art Institute's collection of 20th-century furniture is a tall case clock (front cover, figs. 1, 9–10) designed jointly by Josef Hoffmann (1870–1956) and Carl Otto Czeschka (1878–1960) and made at the Wiener Werkstätte (Vienna Workshops) around 1906. The Hoffmann/Czeschka clock, the first important piece of Wiener Werkstätte furniture in the Viennese Art Nouveau style to enter the museum's collection, is a striking example of the individually executed luxury goods produced by the skilled community of craftsmen in all media that comprised the workshops. The museum owns two other pieces of furniture designed by Hoffmann, a side chair (fig. 2), designed about 1904 for the Purkersdorf sanatorium (see below), and a reclining arm chair (*Sitzmachine*) (fig. 3), designed the next year. Produced in the Viennese furniture factory of Jacob and Josef Kohn, the two chairs are fine examples of the objects conceived for multiple or "mass" production that were executed to Hoffmann's designs outside the Wiener Werkstätte. In addition to these pieces of furniture the other objects of Werkstätte origin owned by the museum include a silverplated compote, designed in 1909 by Dagobert Peche, and several examples of small glass tableware dating from the 1920s. A large carpet designed by Hoffmann for his patron Fritz Waerndorfer (see below) was recently acquired by the Department of Textiles.[1]

The addition of the clock confirms the Art Institute's commitment to acquiring works of the highest quality and importance in order to illustrate, with individual chef d'oeuvres, the height of achievement in the decorative arts in Europe. Just as the splendid French Rococo wall clock of about 1735 attributed to Jean Pierre Latz, the German secretary desk of about 1775 made by David Roentgen, the French commode of 1770/80 by Jean Henri Riesener, and the English Gothic Revival settee of about 1830 designed by Augustus Welby Northmore Pugin for Windsor Castle are all masterpieces of their type in the collections,[2] so, too, the Hoffmann/Czeschka clock is a tour de force of design and craftsmanship, as well as an eloquent expression of early modern design in Vienna. Its plain, white-painted case, almost mystical in its simplicity and purity, gives it an architectural presence. On the other hand, its facade is totally decorative, from its dome-enclosed face, enriched with fastidiously wrought hands evocative of contemporaneous Viennese jewelry, to its elaborate, glimmering door worked in matte and polished repoussé gilt brass. The door's enigmatic, symmetrical design features a stylized Tree-of-Life motif with meandering, reversing spirals on which odd birds perch. Characterized by a masterful blend of contrasting qualities—with the rigidity of its form set against the fluidity of its decoration, and the simple, white-painted wood competing with the brilliance of golden metal—the clock nonetheless is a work of great balance, harmony, and dignity that reveals much about the artistic and social climate of Vienna just after the turn of the century. To comprehend the ideas that permitted the genesis of such an object in Vienna, however, requires an understanding of influences affecting Vienna from abroad.

At the end of the 19th century, the arts in Vienna, as in many other European centers, were beginning to reflect a reform movement that had its foundations in England. In the second half of the century, the English artist/craftsman William Morris (1834–1896) had been the most outspoken apostle of reform in art and society, devoting all his energies to effecting the changes in which he so passionately believed. Morris had examined the architecture, art, and manufactured goods around him that were caught up in the eclecticism and historical revivals of the post-Industrial Revolution. Manufacturers were turning out cheaply made, poorly designed objects in which

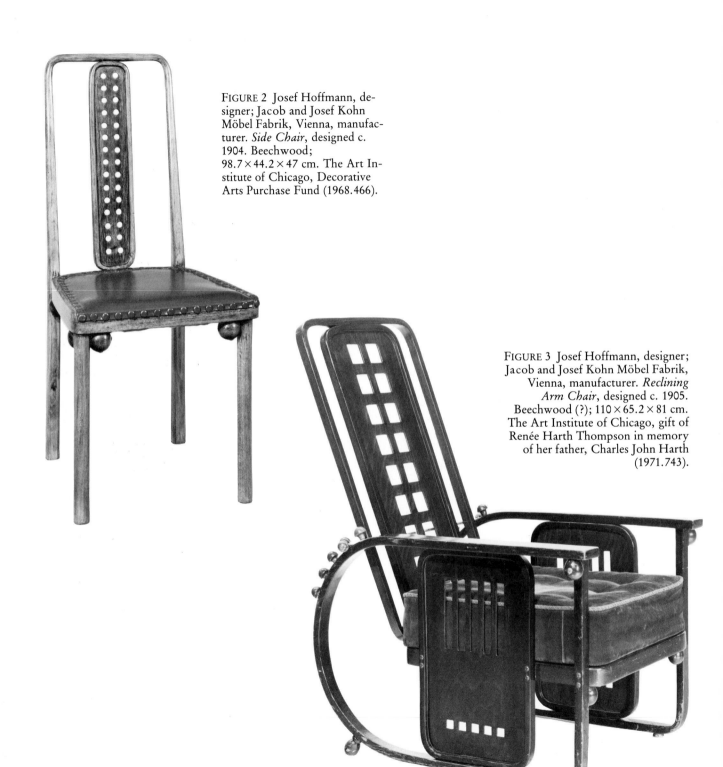

FIGURE 2 Josef Hoffmann, designer; Jacob and Josef Kohn Möbel Fabrik, Vienna, manufacturer. *Side Chair*, designed c. 1904. Beechwood; 98.7 × 44.2 × 47 cm. The Art Institute of Chicago, Decorative Arts Purchase Fund (1968.466).

FIGURE 3 Josef Hoffmann, designer; Jacob and Josef Kohn Möbel Fabrik, Vienna, manufacturer. *Reclining Arm Chair*, designed c. 1905. Beechwood (?); 110 × 65.2 × 81 cm. The Art Institute of Chicago, gift of Renée Harth Thompson in memory of her father, Charles John Harth (1971.743).

skilled craftsmanship played no part and the relationship of ornament to object had been lost. These products were not something in which their makers could take pride. Morris observed that, in the Middle Ages, the creation of useful objects or applied arts had been central to daily life and concluded that, by the 19th century, contemporary artisans had been separated from the roots and function of their art, which as a result had become debased and trivialized. Like his contemporary, the critic John Ruskin (1819–1900), Morris believed that the reinstitution of handcraftsmanship and communities of workers resembling the guilds and workshops of the past would restore integrity to the object and give to the artist/craftsman a sense of value and worth as a human being.[3] Thus, not only did he feel the need to reform style, decoration, and aesthetics, but also the actual social conditions of art and artists.

In 1861, when Morris established the firm Morris, Marshall, Faulkner, Fine Art Workmen in Painting, Carving, Furniture, and Metals, it was with the noble and revolutionary concept that simple, well-designed objects for daily living could be had by all economic classes. Morris's example and ideas exerted a profound influence on a generation of artist/craftsmen, many of whom, in turn, organized guilds or societies where artists collaborated in the production of objects as works of art. The Arts and Crafts Movement, as this trend came to be known, succeeded in breaking down the barriers that had grown up in the 19th century between the fine and applied arts. Following Morris's guiding spirit, his disciples did much to help disseminate throughout Europe and the United States the tenets of the Arts and Crafts Movement through the influential English art publication *The Studio*, initiated in 1893, and through participation in exhibitions within and outside England.

In Vienna, an event occurred in 1897 that heralded the beginning of a new artistic climate in that city. Irritated by the management of the Künstler Haus (artists' house), Vienna's traditional artists' gallery, eighteen dissident artists and architects, led by the painter Gustav Klimt (1862–1918), severed their ties with the establishment and formed a "Secession" group, the Vereinigung Bildende Künstler Oesterreichs (Austrian Fine Arts Association), following a similar action taken by artists in Munich in 1893. Convinced that the arts in Vienna were stagnating, the Secessionists sought to reinvigorate them through an ambitious program of exhibitions in which they invited foreigners to participate, the idea being that exposure to the best new art (Art Nouveau) from outside of Austria would inspire local artists. By the time they staged their first exhibition in 1898, the local group had more than doubled. Sixty-one "corresponding" members—foreign artists who sent work to the exhibition—further enriched the new movement with their strength and diversity. For Vienna, the most revolutionary concept of these Secessionist exhibitions was that they included works of art in all categories—not only painting and sculpture, but also posters, architectural drawings, and the whole range of decorative arts. Thus, before the end of the century, the reforms that had allowed the new artistic spirit to flourish in England and Scotland and in other countries like France and Belgium also began to have an impact in Austria.

One of the principal founders of the Vienna Secession was Josef Hoffmann. Born in Pirnitz, Moravia, in 1870, he studied as a youth in a public school for crafts in Brno. Entering the Vienna fine-arts academy in 1892 at the age of 22, Hoffmann became a student of Karl von Hasenauer, one of the architects of Vienna's ambitious Ringstrasse development.[4] When Hasenauer died in 1894, Hoffmann became a pupil of Otto Wagner, Hasenauer's successor at the academy and a more progressive architect. Wagner championed the use of new materials to create a modern Viennese architectural style. Following Hoffmann's graduation from the academy in 1895, he competed for and won the coveted Prix de Rome, a scholarship that allowed him to study architecture in Italy and along the Dalmatian coast. Returning to Vienna the following year, he worked in Wagner's studio along with a former classmate, Josef Maria Olbrich (1867–1908), a promising young architect/designer who was also strongly influenced by his teacher. Two years after he helped found the Secession, Hoffmann was appointed professor at the Kunstgewerbeschule (School of Arts and Crafts); he taught there until 1941, long after his reputation as an innovator had been eclipsed. He was active in the Secession until 1905, designing many of its exhibitions as well as a diverse group of decorative arts included in them.[5]

Initially, Secessionist artists like Hoffmann, Olbrich, and Kolomon Moser (1868–1918) began to concentrate on making objects to suit the needs of the approaching new century—works that were not necessarily grounded in the traditions and materials of the past. Following their credo that art is for everyone, they inveighed against the sorts of luxury goods that were not essential to daily life. Designing furniture, metalwork, ceramics, glass, and textiles, as well as complete interiors, they created an Art Nouveau style that became unique to Vienna and that was, at the same time, visibly different from the curvilinear and tendrillike forms of French and Belgian Art Nouveau. Their early furniture designs, dating before 1900, tended to be two-dimensional and angular in quality, with severe, simple shapes (see fig. 4). Furniture in the "plank style" (*brettelstil*), as it came to be known, was made of inexpensive, soft woods, which permitted the creation of simple geometric decorations that could be

Prof. JOSEF HOFFMANN

Entwürfe

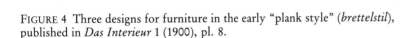

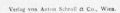

Verlag von Anton Schroll & Co., Wien.

FIGURE 4 Three designs for furniture in the early "plank style" (*brettelstil*), published in *Das Interieur* 1 (1900), pl. 8.

cut out easily with saws. The furniture was reasonably priced and thus affordable to all: the reformers expected, of course, that their wares would appeal to members of the working and lower-middle classes. This idealistic early philosophy of the Secessionists, eschewing goods for a luxury market, would disappear with the development of the Wiener Werkstätte a few years after the turn of the century and be replaced by a more pragmatic, commercial attitude.

At the Secessionists' first exhibition, in 1898, Hoffmann exhibited his *Ver Sacrum Zimmer* (Sacred Spring Room), a completely furnished room intended to convey the equal status of the decorative and fine arts.[6] The room, and the "plank style" in which it was designed, owed much to the inspiration of English artists like Charles Robert Ashbee, a follower of Morris who had founded his Guild and School of Handicrafts in 1888 (see fig. 5). Many examples of furniture and decorative

objects by Ashbee and his contemporaries had been published in *The Studio* prior to the formation of the Secession, as well as in German-language publications like *Kunst und Kunsthandwerk* and *Dekorative Kunst*.

The eighth Secessionist exhibition, of 1900, was a seminal event. Its impact on Viennese decorative arts was felt more powerfully than any of the other Secessionist exhibitions before or after. Organized by Hoffmann and Moser, its primary focus was the design of interiors and objects, the most influential of which were by the British participants. A group known as the Glasgow Four—Scottish architect/designer Charles Rennie Mackintosh; his wife, the artist Margaret Macdonald; and her sister and brother-in-law, Frances and Herbert MacNair—collaborated to produce a tea room (fig. 6). Their use of white as the predominant color for the walls, woodwork, and much of the furniture stunned the Viennese. Although white rooms and furniture had been published in the art maga-

zines, the tea room exposed the Viennese directly to a bold use of this stark color—with all of its allusions to cleanliness and its connotations of light and sensuality—in connection with a spare installation. Even the entries of other foreign artist/craftsmen such as Ashbee and the Belgian Henri van de Velde may have seemed timid in comparison to the spectacular ensemble from Scotland.

The ideas and designs from England and Scotland served as a kind of aesthetic transfusion for artists like Hoffmann and Moser. To this influence can be traced several elements in the Art Institute's tall case clock—the use of white, the object's geometric and sculptural spareness—not to mention the concept of workshop production. In 1902, the two artists visited Ashbee's London workshops: apparently, they also went to Glasgow to see the Mackintoshes.[7]

The Wiener Werkstätte came about through the joint efforts of Hoffmann, Moser, and Fritz Waerndorfer, a man of considerable means who was both a friend and a patron of Secessionist artists. Because he had studied in England early in the 1890s, he was well versed and current in his knowledge of English design and designers. Following the eighth Secessionist exhibition, Waerndorfer confirmed his serious interest in the new, modern style by commissioning a music room from Mackintosh and a dining room from Hoffmann.[8] His commitment to promoting avant-garde art in Vienna went beyond mere patronage. In June 1903, with the financial backing and management of Waerndorfer, the design expertise of Hoffmann and Moser, and the skills of myriad craftsmen specializing in cabinetmaking, metalworking, jewelry, leatherworking, bookbinding, textiles, and other crafts, the Wiener Werkstätte-Produktiv-Gemeinschaft von Kunsthandwerken in Wien was born. It would continue until disbanded by Hoffmann in 1932.

From the beginning, the workshops were intended to be a commercial enterprise. By the turn of the century, it was becoming clear that Viennese reform furniture and objects were not attracting the lower economic classes but, rather, were being purchased by avant-garde intellectuals and members of the upper class. The reformers were forced to adjust their thinking about their products in order to accommodate the actual market—the affluent patrons and clients for whom luxury goods were affordable and desirable. In his now-famous 1905 *Manifesto of the Wiener Werkstätte*, Hoffmann dramatically expounded its Morrislike goals:

We wish to create an inner relationship linking public, designer, and worker and we want to produce good and simple articles of everyday use. Our guiding principle is function, utility our first condition, and our strength must lie in good proportions and the proper treatment of material. We shall

FIGURE 5 Charles Robert Ashbee (English, 1863-1942), designer. *Vertical cabinet*, designed c. 1900. Photo: *Kunst und Kunsthandwerk* 3 (1900), p. 181.

FIGURE 6 Charles Rennie Mackintosh (Scottish, 1868-1928), Margaret Macdonald (Scottish, 1865-1933), Frances (1874-1921) and Herbert MacNair (1868-1955), Scottish, designers. *Tea Room*, exhibited at the Eighth Secessionist Exhibition, Vienna, 1900. Photo: *Dekorative Kunst* 8 (1901), p. 175.

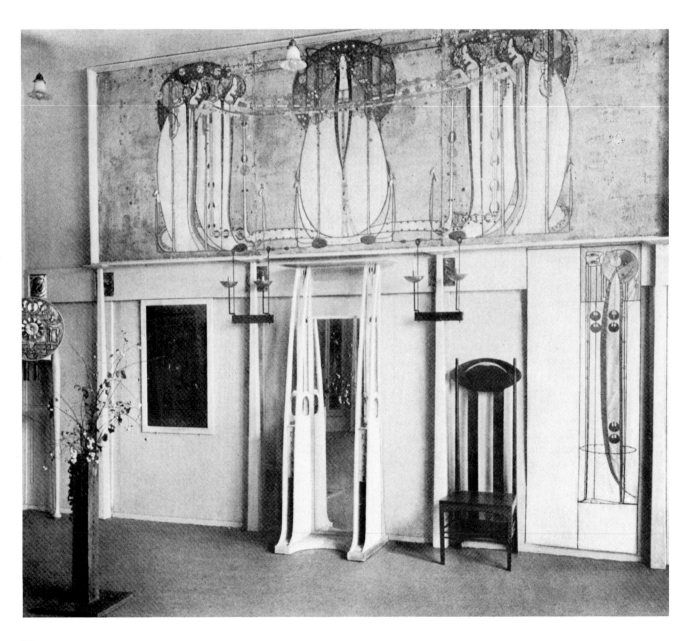

seek to decorate when it seems required, but we do not feel obliged to adorn at any price. . . . Handicrafts must be measured by the same standards as the work of a painter or sculptor.[9]

In the next few years, the workshops' staff expanded as several enormous commissions were undertaken: to re-model and furnish a hunting lodge for Karl Wittgenstein at Hochreit, and to build and completely furnish the sanatorium at Purkersdorf, as well as the luxurious Brussels residence of Adolphe Stoclet. One of the new employees was the artist/designer Carl Otto Czeschka. Born in Vienna, Czeschka, like so many of his Viennese contemporaries, studied at the fine-arts academy, where he was a student of the artist Christian Griepenkerl. He exhibited with the Secessionists in 1900, 1902, and 1904. In 1902, he became an assistant at the Kunstgewerbe-schule, where he taught drawing and graphics. At Hoffmann's urging, Czeschka joined the design staff of the Werkstätte in 1904. Prior to that time, he had worked principally as a graphic artist; after 1904, he broadened his activities to include designs for metalwork, jewelry, furniture, textiles, costumes and stage sets, and ornamental decorations. In 1908, Czeschka left Vienna for Hamburg to accept a position as professor at the art school there. He resided in Hamburg until his death in 1960. By 1906, Czeschka was singled out as "another power" in the Werkstätte: "[His] pupils are already giving evidence of his influence. His forte lies in decorative work."[10] The article was illustrated by one of Czeschka's best-known creations, an enormous repoussé silver-gilt and ivory chest made in the workshops, commissioned by the Skoda factory at Pilsen for the visit of Emperor Franz Josef (fig. 7). Clearly, the workshops were intent upon creating and advertising luxury items like the Art Institute's clock.

The earliest published reference to the clock dates from 1907, when it was illustrated in the influential German art magazine *Deutsche Kunst und Dekoration* (fig. 8). Alongside the illustration of the clock appears the mono-gram of Josef Hoffmann and the words "Treibarbeit von Czeschka" (embossed by Czeschka). The clock was one of 68 objects and interior views illustrating a series of articles on the Wiener Werkstätte. The distinctive mono-grams of Hoffmann, Moser, and Czeschka appear by the objects or interiors each of them designed. This use of identifying monograms in conjunction with handsome reproductions of important objects in the magazine was common after 1904 and ceased before the end of the decade. Facilitating instant product recognition in the magazine during the formative years of the workshops, the monograms today help to document the designers, as well as the dates of the objects.

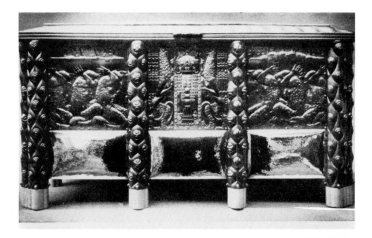

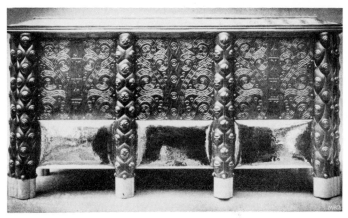

FIGURE 7 Carl Otto Czeschka, designer; Wiener Werkstätte, manufacturer. *Chest* (front and back views), designed c. 1905/06. Repoussé, silver gilt, and ivory. Photo: Vienna, Oesterreichische National-bibliothek (PK 1249). Photo: *Deutsche Kunst und Dekoration* 18 (Apr.-Sept. 1906), p. 419.

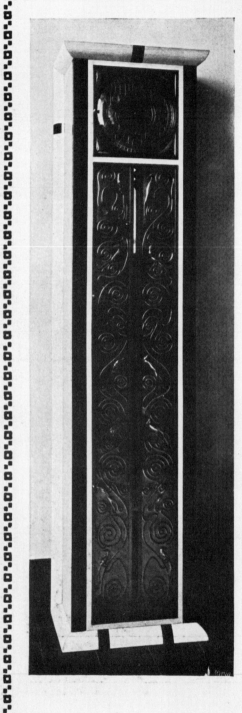

Stehuhr.
Holz
weiss poliert.
Treibarbeit
von
Czeschka

als mit praktischen Gründen entschieden. — Einige haben erwähnt, im Anfang könnte der Zeichner einige Entwürfe für Ausstellungszwecke auf eigene Kosten ausführen lassen. Damit ist angedeutet, daß der entwerfende Künstler sich im allgemeinen als Zeichner fühlt und mit der Ausführung seiner Entwürfe nichts zu tun haben will. Vielleicht würde es doch manchem von ihnen mehr entsprechen, teilweise wenigstens auch praktisch ausführend tätig zu sein. Der Handwerker, der kleine Fabrikant, die zugleich zeichnen können, sind gegenüber dem bloßen Zeichner doch stark im Vorteil. Man könnte eine solche Entwicklung, die den kunstgewerblichen Zeichner vor dem zeichnerisch gebildeten Kunsthandwerker, numerisch wenigstens, zurücktreten läßt, eigentlich nur begrüßen.

Eingegangen waren zu diesem Wettbewerb 24 Arbeiten; die Preise und lobenden Erwähnungen wurden folgenden Autoren zuerkannt:

I. Preis: B. Kolscher, Architekt und Zeichenlehrer an der Tischlerfachschule, Detmold. II. Preis: D. G. Rimstein—Hannover. III. Preise: Zeichenlehrer Hugo Friedrich—Leipzig, August Kuth—Düsseldorf, Zdenko Schindler—Lobositz i. Böhmen, Architekt E. Wendel—Pfalzburg i. Lothringen, Dr. Techn. Hans Ungethüm—Wien.

Lobende Erwähnungen: B. Kolscher, Architekt und Zeichenlehrer an der Tischlerfachschule, Detmold, Paul Schmidt—Darmstadt, Paul Levi—Charlottenburg, Jakob Ruegg—Turgi (Schweiz).

Wir wollen nunmehr einige der Einsender selbst zu Worte kommen lassen. Das Beste, was sie dem Anfänger zu raten wissen, ist, wie selbstverständlich: Energie, Ausdauer und etwas geschäftliches Geschick. J.

ERSTER VORSCHLAG.

B. Kolscher—Detmold.

Um wirklich praktische wertvolle Entwürfe für das Kunstgewerbe anfertigen zu können, muß man genau über die Leistungsfähigkeit der Betriebe und der Maschinen, mit welchen man zu arbeiten hat, Bescheid wissen, ebenso über alles, was in dem Fache zur Zeit auf den Markt gebracht wird und über die Herstellungs- und Verkaufspreise. Diese Kenntnisse erwirbt man sich, indem man mit den betreffenden Betrieben einen ständigen Verkehr anbahnt, dadurch, daß man möglichst oft mit seinen Skizzen und Ideen die Inhaber und Leiter der Geschäfte aufsucht und auch be-

FIGURE 8 Hoffmann and Czeschka. *Tall Case Clock* (figure 1), reproduced in *Deutsche Kunst und Dekoration* 19 (Oct. 1906-Mar. 1907), p. 466, with the Wiener Werkstätte monogram of Josef Hoffmann and the caption "Treibarbeit von Czeschka" (embossed by Czeschka).

Hoffmann's training as an architect and Czeschka's as a graphic artist determined the nature of their contributions to the Art Institute's piece, as well as to other workshop projects in which they were involved at the same time. Let us turn first to Czeschka's participation, beginning with the clock doors decorated with birds and meandering vines (fig. 10, front cover).

The clock was designed during the same period as the hunting lodge project at Hochreit mentioned above. For the lodge, Czeschka provided designs for furniture, fabrics, embossed metal plaques, and painted decorations which treat themes from nature and the hunt.[11] For the upper part of the entry vestibule, Czeschka designed colorful panels with birds (fig. 11). It is interesting to note that the style and subject matter of the decorations for the lodge parallel not only those of the museum's clock but also other Werkstätte designs of the period. Each of two doors in that room is decorated with a motif perhaps conceived by Hoffmann (fig. 11), in which a pair of birds facing one another perch on stylized, meandering vine-like scrolls, not unrelated to the scheme of the clock door.[12] In Moser's well-known poster for the Jacob and Josef Kohn furniture company (fig. 12), the central, frontal figure is clothed in a garment decorated with an undulating, scrolled vine, next to which appear other scrolled elements with birds perched on foliage.[13] Thus, this motif, or variations on it, was not unique to Czeschka but was used as well by other major designers of the Werkstätte.

The source for this stylized decoration can be traced to the work of Gustav Klimt, such as his *Beethoven Frieze* shown in the Secessionist exhibition of 1902, or his 1898 poster for the first Secessionist exhibition, in which a classical figure wears a helmet adorned with scroll decorations. Klimt and other Viennese artists trained in the academy in the last decade of the 19th century were exposed to design theories like those in Alois Riegl's *Stilfragen* (Berlin, 1893), a design history that Klimt and his contemporaries must have known. While probably not providing specific designs for particular works of art, studies such as Riegl's (see fig. 13) must have enriched Klimt's visual vocabulary. Like Riegl, the artist was enormously influenced by designs and decorations from Mycenae, Byzantium, and other ancient cultures. During Klimt's visit to Ravenna in 1903 to see the city's famed early Christian decorations, he must have observed in the mosaics such typical motifs as the Tree of Life with birds and acanthus scrolls.

Golden Trees of Life with stylized birds adorn each of two mosaics—*Expectation* and *Fulfillment*—that Klimt designed for the dining room of the Palais Stoclet (see fig. 14). The Palais Stoclet is the Wiener Werkstätte's preeminent example of what was called *Gesamptkunstwerk* (a total work of art). Hoffmann was its architect, and

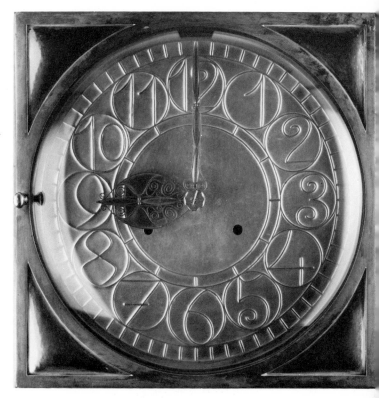

FIGURE 9 Hoffmann and Czeschka. *Tall Case Clock* (detail showing face). Photo: William Frederking, Chicago.

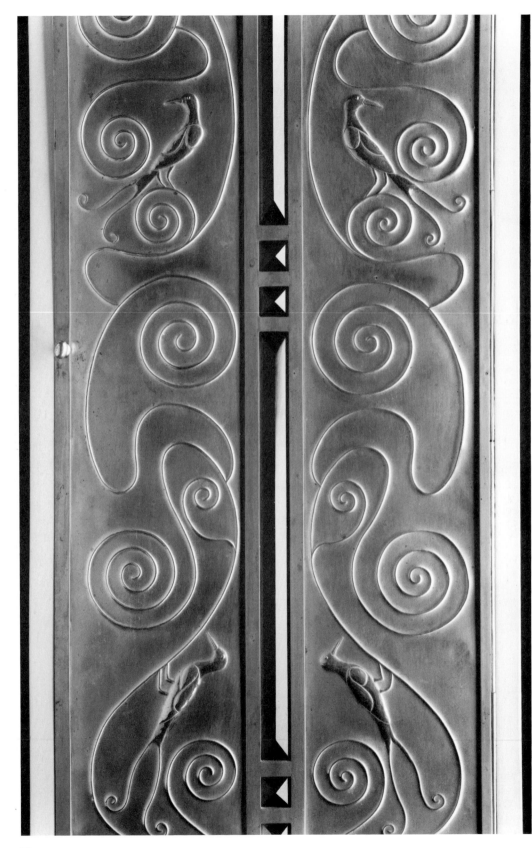

FIGURE 10 Hoffmann and Czeschka. *Tall Case Clock* (detail showing doors). Photo: William Frederking, Chicago.

FIGURE 12 Kolomon Moser (Austrian, 1868-1918). Poster for the Jacob and Josef Kohn Möbel Fabrik, Vienna, c. 1905/06. Photo: *Deutsche Kunst und Dekoration* 19 (Oct. 1906-Mar. 1907), p. 78.

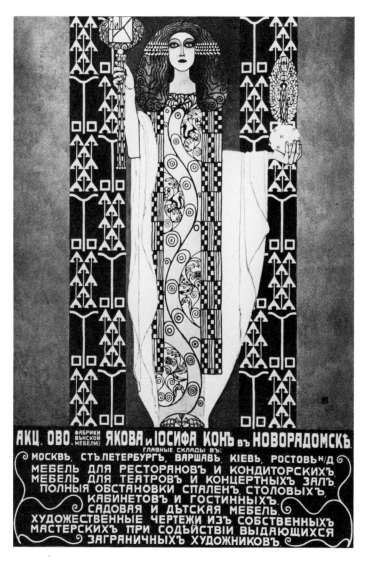

FIGURE 11 Hoffmann and Czeschka. Vestibule of Karl Wittgenstein's hunting lodge at Hochreit, Austria, completed 1906, showing panels with birds designed by Czeschka. Photo: *Deutsche Kunst und Dekoration* 19 (Oct. 1906-Mar. 1907), p. 451.

Fig. 185.

Kopfleiste aus einer armenischen Miniaturhandschrift des 11. Jahrh.

Czeschka and Klimt were major contributors. Since the Stoclet friezes were commissioned in October 1906 but not executed until 1909 and not installed until 1911, it is unlikely that they provided any kind of direct inspiration for Czeschka's clock decoration. Nonetheless, Klimt's work clearly exerted a powerful influence on his Werkstätte colleagues, who evolved a common decorative language.

Gilt brass, along with brass and gilt bronze, had been featured as a material for clock faces and decorative mounts, not to mention the less visible working parts, in Europe for several centuries. In the instance of the Hoffmann/Czeschka clock, however, the repoussé gilt-brass plaques and face serve both an architectural and a decorative function. The extravagant use of this sumptuous, hand-wrought material, along with the cut-glass prisms, ornate silver-gilt clock hands, and expensive, inlaid imported woods—all time-consuming hand processes—conveys a sense of costliness and luxury.

One sees in Werkstätte objects of this period like the Art Institute clock a deliberate moving away from the early Secessionist concepts of simple, plain, functional objects in the tradition of Morris. The design and decoration of the clock reflects the needs of Werkstätte artists to execute truly modern, progressive designs and to satisfy as well the tastes of its sophisticated, privileged clientele. Certainly, the case's radically simple outlines, pure colors, gridlike inlays, and forthright wooden structure represent an attempt to create an honest, abstract, formal language. On the other hand, the clock's jewellike bronze face (fig. 9), doors (fig. 10, front cover), and cut glass lend a luxurious quality to the piece and introduce stylized biomorphic motifs relating to the Art Nouveau movement, which had reached its peak by this time. In its form, decoration, and materials, it brilliantly embodies two diverse tendencies characteristic of the Werkstätte during a period of transition.

Left
FIGURE 13 Page showing a Byzantine miniature with the sort of scrollwork with birds that would be used as motifs by Wiener Werkstätte artists, from Alois Riegl, *Stilfragen. Grundlegungen zu einer Geschichte der Ornamentik* (Berlin, 1893), p. 329.

FIGURE 14 Josef Hoffmann, architect; Gustav Klimt (Austrian, 1862-1918), designer. Dining room of the Palais Stoclet, Brussels, showing Klimt's mosaic *Fulfillment*, 1909. Photo: Eduard F. Sekler, "Mackintosh and Vienna," *Architectural Review* 144 (Dec. 1968), fig. 37.

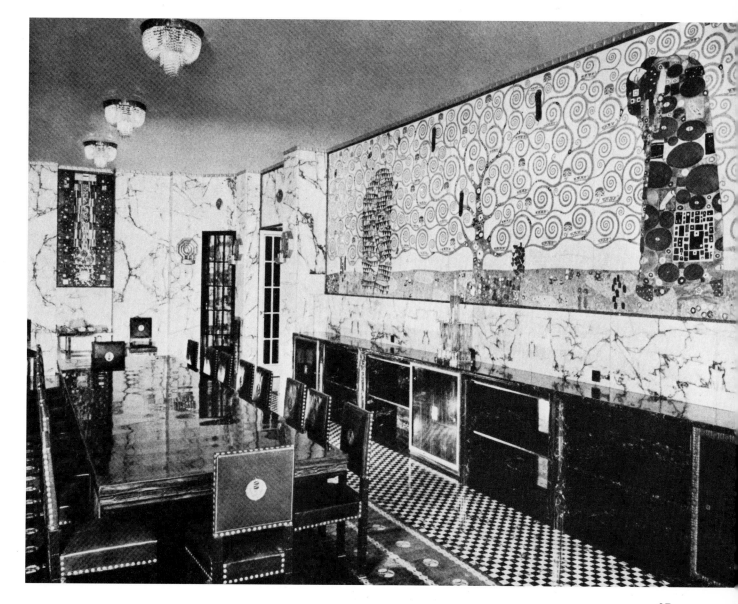

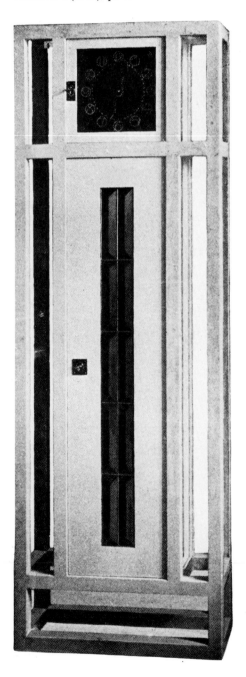

FIGURE 15 Josef Hoffmann, designer. *Tall Case Clock*, designed 1903. Photo: *Das Interieur* 4 (1903), p. 8.

Indeed, one need only compare the Art Institute's clock of 1906 with one Hoffmann did a few years earlier for Dr. Friederich Spitzer (fig. 15) to study the evolution of his own design. The earlier clock is devoid of ornamentation except for the decorative effect of the painted, gridlike framework which at once supports and contains the architectonic case and the vertical row of paired prisms set into the case door. It appears weightless, fragile, and precarious, almost defying gravity; floating above the surface of the floor, it needs a wall behind it for visual support. Earlier examples of Hoffmann's white, "plank-style" furniture, like the Spitzer clock, either were built-in or used in modules with shelves, cabinets, or bookcases. With the design of the Art Institute clock, Hoffmann created a more powerful and unified sculptural form; yet, he still conceived the clock as related to the wall. By wrapping the edges with a generous rounded molding, he insured the clock's harmony with the tall, dadoed or paneled walls he created for some of his interiors at this time. The molding tends to unify the clock as it wraps around it; at the same time, as the eye is led up the sides and pushed forward around the top and around the base, the sense of the clock's three-dimensionality is enforced. The inspiration for this particular application of a molding was not to be found in Austrian examples but rather in British ones rooted in the Arts-and-Crafts-Movement woodworking process. Influenced by these sources, Hoffmann used moldings in many of his architectural designs, notably in the Purkersdorf sanatorium and in the Palais Stoclet, where they literally join the edges of exterior walls.

In the Art Institute clock, Hoffmann introduced other new ideas as well. His juxtaposition of a stark, volumetric form covered with textured white paint[14] with the refined ebony and mahogany inlays of the freestanding columns and the flat decorative bands of inlay (two on the base, one at the top, and one on each side) is not only unusual but evocative. Lest we accept the columns in the classical sense, as elements of support, Hoffmann consigned them to a purely decorative role. The curious application of flat bands of inlay cutting vertically into the path of the encircling molding playfully conjures up the association of vestigial feet, arms, and head. With its round face, a "torso" made shapely by Czeschka's curving pattern, and the suggestive inlays, we may ask whether Hoffmann was suggesting in this clock an analogue to the human figure. In any case, these intentional contrapuntal choices create a rich, visual effect. Hoffmann's idiosyncratic use of moldings in the Art Institute clock can be seen in other of his architectural and furnishing designs of the period. In a commission of the same year, the decoration of the apartment of a Viennese physician, Dr. Hermann Wittgenstein (see fig. 16), Hoffmann incorporated a feature found on

FIGURE 16 Josef Hoffmann, designer/architect. Salon of Dr. Hermann Wittgenstein's apartment, Vienna, designed 1906. Photo: *Deutsche Kunst und Dekoration* 18 (Apr.-Sept. 1906), p. 457.

the museum's clock case—a prominent, rounded molding. To unify an inglenook (a built-in seating area near a fireplace) and adjacent bookcase with the rest of the salon, Hoffmann employed a similar molding to physically and visually connect all the modules of the white paneling and supporting elements. A flat appliqué appears on the molding at regular intervals at the juncture of supporting elements, as if to punctuate and call attention to the room's structural relationships. Like those used on the clock, this molding is purely decorative.[15]

The name of the original owner of the Art Institute clock has been lost. It was in the possession of a member of the Waerndorfer family, but without more concrete documentation, one cannot assume, as is tempting to do, that the clock belonged to Fritz Waerndorfer. Further studies of archival material in Vienna may someday reveal its first owner. It is also possible that the clock may have been made not as a private commission but as an exhibition piece. The fact that it was featured in the pages of *Deutsche Kunst und Dekoration* suggests that it was considered a major example of what the workshops could produce.

In the tall case clock, Hoffmann and Czeschka merged, as we have seen, the two divergent aspects of design and decoration that characterize objects produced during the early years of the Wiener Werkstätte. Hoffmann's rigid, stark, architectural forms, relieved by geometric dark-and-light-patterned decoration; Czeschka's richly ornamented door with its sinuous, evocative decorative panels, and the face enlivened with hands fashioned like jewelry—all create contrasts that are bold, intentional, and inspired. The coexistence here of modest materials and straightforward construction with luxurious, costly, and obviously hand-wrought decoration indicates the philosophical distance the Viennese artist/designers had traveled from the goals of the Arts and Crafts Movement that had inspired Secessionists only a few years before. While the craftsmen and designers still functioned in a commercial workshop situation, the products they created were only for those who could afford their luxury.

Like all great works of art, the Art Institute clock has eloquence and power even when removed from its original context. One can only speculate about how it appeared in an original Wiener Werkstätte interior, with, perhaps, an electric chandelier designed by Hoffmann creating a soft glow that caused the clock's glass prisms and gold face to flash brilliant glints of light in all directions. Seen today in the even, intense light of the museum galleries, the Hoffmann/Czeschka clock is a compelling and beautiful work of art that maintains a perfect equilibrium between its contrasting materials, divergent stylistic elements, and collaborative creation.

NOTES

The author is particularly grateful to Dr. Christian Witt-Dörring, Curator of Furniture and Interiors at the Oesterreichisches Museum für Angewandte Kunst, Vienna, for discussing many aspects of this article; Mrs. Helmut Strauss and Timothy Rigdon for assisting in research; Professor Eduard F. Sekler, Harvard University; and Christine Ivusic of the Princeton University Press for sharing Dr. Sekler's manuscript (see note 11) prior to its publication.

1. Dagobert Peche (Austrian, 1887–1923), *Compote*, 1909, gift of the Antiquarian Society through the Mrs. Burton W. Hales Fund (1978.195). Three pieces designed by Hoffmann: *Champagne glass*, c. 1920, gift of Bessie Bennett (1939.404); *Sherbet cup*, c. 1910, gift of Kelvyn G. Lilley (1975.1029); *Red wine glass*, 1920, gift of J. and L. Lobmeyr (1979.733). *Bowl* (Austrian) 1920/24, gift of Robert Allerton (1927.789). *Water tumbler*, 1931, designed by Adolph Loos (Austrian, 1870–1933), gift of J. and L. Lobmeyr (1979.734). Vase (Austrian ?), c. 1915, gift of Mrs. Howard R. Cannon (1979.29). Josef Hoffmann, *Carpet*, 1902/03, gift of the Auxiliary Board of The Art Institute of Chicago (1984.115). The Department of Textiles also owns a silk-screen printed panel designed by Hoffmann entitled *Santa Sophia*, 1912/17, gift of Robert Allerton (1924.217).

2. Jean Pierre Latz, attr. (German, active in France, c. 1691–1754), *Wall Clock*, c. 1735/40, the Ada Turnbull Hertle Fund (1972.172a-b). David Roentgen (German, 1743–1807), *Secretary Desk*, c. 1775, gift of Count Pecci-Blunt (1954.21). Jean Henri Riesener (German/active in France, 1734–1806), *Commode*, c. 1770/80, Major Acquisitions Fund and Wirt D. Walker Fund (1972.412). Augustus Welby Northmore Pugin, attr. (English, 1812–1852), *Settee*, c. 1827/30, restricted gift of Mrs. Clive Runnells (1972.1132).

3. Of great influence on Ruskin was Augustus Welby Northmore Pugin, an architect and designer. Ruskin admired his insistence on the honesty of structure, appropriateness of decoration, and truthful use of materials. Two other reformers of Pugin's generation, who also came under his influence, were Sir Henry Cole (1808–1882) and architect/designer Owen Jones (1809–1874). Cole sought to improve manufactured wares by designing for manufacturers and encouraging other artists to do so. His distress over the state of manufacturing eventually led to his appointment as the first director of the South Kensington Museum (now the Victoria and Albert Museum), whose collection initially was assembled to inspire and teach designers for industry with choice objects from man's past. Jones, author of *The Grammar of Ornament*, also pleaded for the straightforward use of materials and quality craftsmanship.

4. The Ringstrasse was a late 19th-century urban development in Vienna featuring a ring-shaped boulevard, with public and institutional buildings; it was constructed on the site of old Vienna's royal fortifications in an eclectic mix of architectural styles.

5. Following his design of the installation of the first Secessionist exhibition, he was responsible for those of the fourth (1899), fifth (1899–90), eighth (1900), twelfth (1901), and fourteenth (1902). In 1905, Hoffmann's association with the Secession ended. Along with a substantial group of artists around Gustav Klimt, he decided to withdraw from the Secession in favor of alternative exhibition possibilities in Vienna.

6. *Ver Sacrum* was also the name initially given to the major Secessionist publication.

7. Eduard F. Sekler, "Mackintosh and Vienna," *Architectural Review* 144 (Dec. 1968), pp. 455–56.

8. Peter Vergo, "Fritz Waerndorfer and Josef Hoffmann," *The Burlington Magazine* 964,125 (July 1983), pp. 402–10. These rooms are illustrated in the article.

9. Hoffmann's manifesto, *Das Arbeitsprogramm der Wiener Werkstätte*, was published in Vienna in 1905. A translation is included in Christian Meyer, *Joseph Hoffmann, Architect and Designer, 1870–1956* (Vienna, 1981), pp. 7–10.

10. A. S. Levetus, "Modern Decorative Art in Austria," *The Art Revival in Austria* (London, 1906), pp. Dvi, D67.

11. The Hochreit interiors, along with various objects and decorations, were published in the same issue of *Deutsche Kunst und Dekoration* (19 [Oct. 1906-Mar. 1907], pp. 444–55), as the clock. E. F. Sekler, in *Josef Hoffmann: The Architectural Work* (Princeton, N.J., at press), discusses these themes in the decorations.

12. Another variation on the same theme, also designed by Czeschka and illustrated in *Deutsche Kunst und Dekoration* (note 11), p. 469, is a stained-glass frieze with stylized birds, both facing one another and back to back, perched on scrolled vines. Czeschka's monogram appears next to the illustration.

13. The poster was illustrated in *Deutsche Kunst und Dekoration* (note 11), p. 78, opposite a stained-glass window design by Czeschka.

14. It was initially thought that this aspect of the clock was the result of poor restoration, but C. Witt-Dörring confirms that examples exist of early 20th-century, white-painted Viennese furniture retaining original pigment that exhibit the same uneven texture of brush marks as the Art Institute example.

15. See *Deutsche Kunst und Dekoration* 18 (Apr.-Sept. 1906), pp. 456–57.

FIGURE 1 Claude Gellée, called Le Lorrain (French, 1600-1682).
Panorama from the Sasso near Rome, 1649. Pen and brown ink, brush
and brown wash with white gouache over black chalk and graphite on
buff paper; 168 × 410 mm. The Art Institute of Chicago, Helen
Regenstein Collection (1980.190).

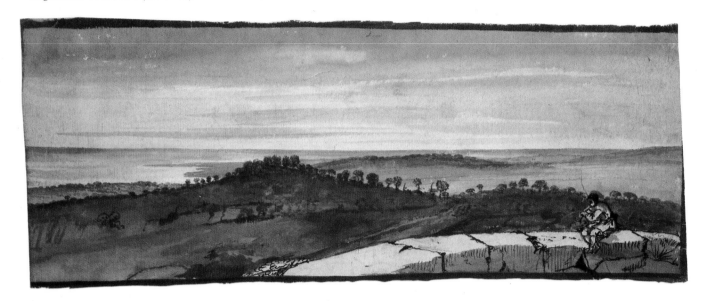

A Panoramic View by Claude Lorrain

MARCEL ROETHLISBERGER, *University of Geneva*

If the painter wishes . . . from the highest mountain peaks to discover panoramic views, and if beyond them the sea on the horizon, he is lord to do so, as he is if he wishes to see from low valleys high mountains, or from high mountains low valleys and shores. And, in fact, whatever exists in the universe, in essence, in reality, or in imagination exists first in his mind, and then in his hands.

LEONARDO DA VINCI, *Paragone*, 19[1]

*P*anorama from the Sasso near Rome (fig. 1), executed in 1649 by Claude Gellée, called Le Lorrain (1600–1682), is one of the premier examples of Western landscape art. The simplicity of the composition, lack of detail, and subtle tones give it a timeless and almost abstract quality. It does not channel our response in a specific way but instead invites us to contemplate aerial perspective, the mystery of space, infinity, and the absolute.

Art historians explain works of art by placing them in their historical context. Ideally, the task of determining the place of each work includes comparison and judgment of quality, but the art-historical process usually leads as well to some leveling and demystification. For the museum curator, on the other hand, the quest for quality is the guiding criterium of selection; while the professed aim invariably will be to search for the best, this ambition is usually curbed by the scarcity and cost of works of art. Harold Joachim, the Art Institute's Curator of Prints and Drawings from 1958 until his death in 1983, acted brilliantly in acquiring the Claude drawing in 1980. This work and another of foliage of the same period in a private collection[2] are the most outstanding sheets among Claude's 1,300 or so extant drawings. It joins two other sheets by the artist in the Art Institute—a drawing of two ships and a figure study for the *Journey to Emmaus*, as well as three drawings by his followers.[3]

Panorama from the Sasso was done on buff paper in deep brown wash over a light preparation in black chalk, with pen used to depict the parapet in the foreground and a few touches of white heightening. In the center right of

the verso appears a large signature in pen, *"lo Sasso Claudio Gillee/I. V fecit"* (see fig. 2). This kind of proud inscription is found only on a number of Claude's very finest sheets; its presence here provides a clue to the artist's own appreciation of the drawing. Though *I. V fecit* means "made in the city [Rome]," it does not prove that the drawing was actually executed in Rome: it is a common formula indicating "Claude from Rome." The drawing in Chicago came to light in 1973, at which time it was reproduced in a Swiss journal.[4] In 1982–83, after its purchase by the Art Institute, it was exhibited for the first time in the Claude exhibition in Washington, D.C., and Paris.[5]

Panorama from the Sasso is in an excellent state of preservation, which can be explained by its history. Many collectors since the time of Claude framed and hung their drawings, which caused designs to fade and paper to turn yellow. Indeed, the majority of Claude's drawings are faded, a condition less disturbing than the irreversible darkening and inadequate restorations of certain of his oil paintings.[6] However, until 1960, the Art Institute sheet was mounted in a volume of 81 of Claude's finest drawings, assembled shortly after his death by his heirs. The volume was most probably acquired by Queen Christina of Sweden, who at that time was residing in Rome (she died in 1689). The collection was bought by Prince Livio Odescalchi (deceased 1711), nephew of Pope Innocent XI, who was reigning at the time of the artist's death. It is thus clear that Claude himself never sold the drawing.

For the drawing to fit into the volume, whose cover

measures 29 × 41 cm, its frame line at the shorter sides was cut by a few millimeters, but enough of the sheet remains to show that the drawing itself was not cut. Before the volume was sold in 1960 by the descendants of Odescalchi to the dealer Wildenstein, *Panorama from the Sasso* and a few other outstanding sheets were removed and held back to be sold individually. (The volume, called the Wildenstein Album and, subsequently, the Norton Simon Album, was recently dismantled and its sheets sold separately.) Thus, in the Art Institute drawing, we are faced with the rare case of a drawing that can be traced back to the artist and that has never been exposed to light; it looks as fresh as it must have in 1649.

It should be pointed out that *Panorama from the Sasso* is not a "typical" drawing by Claude. Within the many varieties of his graphic oeuvre, there exists a type that collectors have preferred to acquire: finished yet spontaneous drawings in pen and wash of a landscape carefully framed by trees on one or both sides. The Chicago sheet conforms to this type in its technique, finish, and natural setting, but it is unusually oblong and, more importantly, open at the sides.[7]

Villa del Sasso ("sasso" is Italian for rock) is a medieval hamlet in the Tyrrhenian coastal hills along the ancient Via Aurelia, about a day's journey from Rome and 25 kilometers south of the Roman harbor town of Civitavecchia.[8] The village, which is 300 meters above sea level, is located in a saddle between Monte Santo, 430 meters high in the southeast, and a lesser hill in the northwest. Another drawing by Claude, dated 1649 (fig. 3),[9] shows the view across the saddle toward Monte Santo, dominated on the upper left by the now-ruined monastery of San Antonio. Behind the village, following the road that leads from the sea inland to Bracciano, the terrain falls off; another drawing, in Haarlem, shows the view from behind looking up to the hamlet and Monte Santo on the left.[10]

FIGURE 2 Signature on the verso of figure 1.

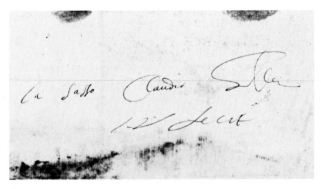

Since the time of Claude, the domain of Villa del Sasso has belonged to the noble Roman Patrizi family (Naro Patrizi Montoro), with which Claude is not known to have had any contact. The village exists almost unchanged today, the only surviving example of a small, fortified agglomeration in the area around Rome known as the Campagna. Its modest houses are grouped around a rectangular courtyard laid out in brick, to which an entrance gate gives access. The village's principal feature is the baronial palace, a rustic, imposing mass consisting of a medieval tower and two large wings built in the 16th and early 17th centuries. As can be seen in figure 3, the face of the wing was once continued along the same axis by a wall that bent around somewhat further down the hill, thereby enclosing the precinct of the palace. It is this very wall, reinforced in the 20th century, that forms the foreground of the Chicago drawing. Thus, the view is from the enclosure of the palace looking south toward the sea. Although Diane Russell stated in her recent Claude exhibition catalogue that the view is from Monte Santo,[11] this is not so. The view from the top of the mountain is far too expansive to lend itself to a pictorial rendering. In the Chicago drawing, Claude consciously chose to omit the lateral hills and avoided any hint of a compositional framing on the sides. With his innate sense of composition, he drew a frame line around most of his drawings. In this instance, no doubt because of the exceptional openness of the setting, the line is particularly wide. It emphasizes the autonomous character of the sheet as a finished work in its own right. The sky and the light indicate a rather overcast day, but upon closer examination, the brightest area of the sky and of the sea at the left suggests that the drawing was done in the late morning, which is further substantiated by the light and shade on the parapet.

Both the drawing's technical execution and composition are masterful. The near-absence of detail—it is limited to the parapet with the figure and to the dotted string of trees—brings to mind Chinese landscapes of the time.[12] Except for the parapet, done with pen and ink, the drawing was executed in pure wash, a difficult technique that Claude rarely used but in which he created some of his finest works. Obviously, he used different brushes for the broad strokes than for the tiny trees. Even the frame line was executed with a brush and not, as was usual for him, with a pen. Penwork, limited as it is here to the foreground, recurs in certain other sheets by Claude (see fig. 5). The technical purity and economy attest to the artist's clarity of thought and mastery of interpretation.

Although the drawing has the spontaneous quality of a "slice of nature," as opposed to the artist's more formally structured paintings, it too is carefully composed. The enframed space is very clearly laid out in four horizontal parallel planes—the bright wall; the dark zone of hills; the

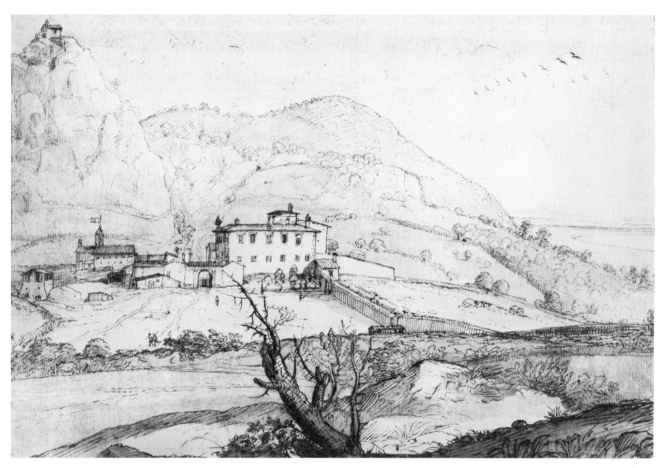

FIGURE 3 Claude Lorrain. *View of the Villa del Sasso*, 1649. Pen and brown ink, brush and brown wash on paper; 256 × 385 mm. Private collection.

lighter, remote background, including the sea; and the sky. This way of organizing the multiple planes of a site is a conscious pictorial simplification of nature that ultimately goes back to Flemish 16th-century landscapes, when three or four planes were set off against one another. Claude's drawing contains no perpendicular connections between the planes. In fact, we have no means of ascertaining the exact distance between them, which contributes to the impression of remoteness. Rather than being distracted by these devices, however, we are impressed with the credibility of the site. Claude enhanced this impression with atmospheric perspective: a landscape bathed in light, in which expanses are not measurable from point to point but appear as successive hilltops emerging above the haze. In painting, this is usually achieved by a progression of color, from a bright brown foreground to a lighter green middle ground to a pale blue distant background.

In this drawing, Claude, with a minimum of means, suggested an observation area from which the landscape is viewed. The spatial sequence develops from the stone wall, which acts as a traditional corner motif forming an intermediary between the viewer and the middle and far zones of an image. Normally a dark silhouette, the *repoussoir* (a foreground element that suggests depth) is here the most luminous portion of the drawing, the area

FIGURE 4 Claude Lorrain. *Tiber Valley*,
1650/55. Pen and ink on paper; 129 × 185 mm.
Folio 32v of sketchbook sold London,
Sotheby, 1982.

in which the white paper was allowed to show through. The shaded inner side of the wall is emphasized by brief pen strokes, the only verticals of the drawing besides the tiny trees. The railing appears all the more imposing, as the youth seated on it and blowing a pipe is comparatively small. While the wall suggests a link with the space of the viewer, it does not provide access to the landscape as would the diagonally placed road or fence found in countless landscapes of the Dutch school and later of the Romantic period. For Claude, the landscape almost always remained a separate realm. He did not provide obvious pictorial devices to connect it tangibly with the viewer. While in the Chicago drawing there is a suggestion of a curved road between two hillocks leading into the distance, it is barely noticeable. And, the head of the youth is linked with the dotted trees that enliven the silhouette of the middle zone.

As to the configuration of lines, they mark an overall, slight ascent from left to right. The coastline is not parallel to the plane of the sheet, but is viewed at an angle. The left-right direction, in turn, is counteracted by the imaginary line extending from the figure—who is directed toward the left—over the main hilltop to the open sea on the left. The gently inflated curve of the parapet contrasts with the slightly concave ascending silhouette of the main hill on the left; this rhythm continues in the light curves of the two distant hills on the opposite side, whereas the

dark zone falls off toward the right. All of these movements are perceived against the unassuming horizon, placed just above the middle of the sheet's height. Except for the far right, where the distant hill barely cuts the horizon, the entire landscape lies below this line. One is reminded of a statement by Claude's contemporary biographer Baldinucci, according to whom "he observed the horizon line to such a degree that he was nicknamed Orizzonte [horizon]."[13] Above the horizon, the movement of the landscape comes to a standstill. The sky is astonishingly empty, dominating the more structured landscape by its great calmness. On the open left side, a long, slender cloud parallels the horizon, whereas on the right the clouds rise very slightly. Brightest at the horizon, the sky frames the image with a darker area of clouds along the top.

A punctilious description of this kind risks demoting a work of art to a clever concoction of compositional recipes; in reality, the drawing forms a visual and stylistic unity in which everything is kept in balance. This analysis merely attempts to explain the impression we perceive. The work's infinite subtleties are combined with strong oppositions. There are powerful contrasts of depth and value between the looming, bright wall; the compact, dark zone with its tiny, crowning trees; and the distant swellings of hills. The drawing embodies both Claude's deep love of nature, nourished as it was by incessant observation, and the theatrical mise-en-scène of the Baroque age of which he was part. The artist had a commanding sense of structure, which comes through in his drawings no less than in his paintings. Since his early years, Claude's mastery of spatial illusion has been the principal agent of his fame. In his paintings, he focused attention on the distant zones, which often contain the rising or setting sun and are enclosed by the darker pictorial framework of the foreground. Admittedly, he did many drawings of details seen from short distances, such as trees; but in *Panorama from the Sasso*, more than in any other known sheet, distance is the true subject. Claude's friend and first biographer, Joachim von Sandrart, who knew him from 1628 until 1635, pointed out Claude's passionate interest in distant views: "We often painted together after nature in the countryside, but whereas I only looked for good rocks, tree trunks, trees, cascades, buildings, and ruins suitable for the adornment of histories, he on the contrary painted only in a small format the most remote parts of the middle ground, dissolving toward the horizon and the sky, in which he was a master."[14] He could easily have been describing the Chicago drawing, were it not for the difference of date.

Claude always saw in landscape a harmonious setting for man. Human figures—pastoral, literary, or biblical—appear in every one of his paintings and in nearly all of his

drawings that present a panoramic view. Landscape as a cosmic experience, dwarfing and overpowering man, was to become a vision of the Romantic age. In the Chicago drawing, the foreground consists exclusively of man and his constructed environment, while the landscape—except for the hint of a road—contains virtually no human trace. But this duality does not express an abyss. The humble piper in *Panorama from the Sasso* establishes both human scale and spiritual meaning, suggesting time, sound, and loneliness. The figure is not lost in the contemplation of the landscape and infinity; instead, he turns toward the viewer and to his instrument, his absorption with his music constituting his active response to the vast space. The meaning of this figure thus is fundamentally different from those in Romantic paintings who are depicted from the back and gaze into the landscape. Despite assertions to the contrary, no Renaissance theory of harmony between music and nature is applicable here.[15] Against the background of modern urban life, one may tend to read into the drawing a more acute sense of solitude, a theme that was to be developed in painting, literature, and music in the course of the 19th century.

Claude had long been familiar with the coastal area near the Sasso. In the late 1630s, he drew Civitavecchia, the nearby Santa Marinella, and the castles of Palo and Santa Severa.[16] Of the Sasso, there exist six drawings, more than of any other site with the exception of Civitavecchia. What brought him there is not known; possibly, it was a summer vacation. Since two of the drawings are dated 1649 (fig. 3 and a view of the Monte Sassone cliffs below and to the west of the village[17]), the others must have been made during the same sojourn as well. While the Chicago drawing, the masterpiece of the group, might in theory date from a few years later, the differences between it and the others have to do with concept, not chronology. The other sheets, besides figure 3 and the view of the Sassone cliffs, are a finished and unfinished view of the Sasso village from opposite sides, and the view from the valley behind cited above.[18] In three, Claude's main concern was the precise rendering in pen of the group of houses. In figure 3, the landscape portion, surprisingly enough, is quite unlike the actual setting. The rocks are exaggerated in height, and the inclusion of the sea combines two different views. The truth is that the Sasso region is not exciting; Claude probably felt that it needed adjustment and augmentation in order to qualify as an image. This is not quite the case for the panoramic view toward the sea. While the Chicago drawing reflects the view accurately enough, it is first and foremost an artistic interpretation. A photograph of the site would reveal nothing comparable, for the actual landscape is duller, less structured, and does not form a self-contained image. It is no accident that no

other artist is known to have drawn this spot. Claude had to limit the view on four sides and to shape the selected segment into a coherent composition. In a drawing of this kind, "nature" loses much of its importance in favor of "drawing."

The problem of transposing nature into art, inherent in every representation of landscape, arises with particular poignancy in this work. While it has always been claimed that Claude's so-called nature drawings, as distinct from his preparatory studies for paintings, were done on the spot—and from Sandrart we know that he in fact painted and sketched out-of-doors—we may ask whether the artist did elaborate drawings like this one in the studio, possibly with the help of quick sketches done outside. We shall never know for sure, and after a certain point it hardly matters. What does seem important is to recognize the high degree of stylization and transformation that exists in a work like that in Chicago. Three kinds of indications need to be considered. First are the frame lines: while most of them are neatly drawn, with or without a ruler, others are shaky and done freehand, which points to an unstable support, out-of-doors (see fig. 5). Second are the rare, explicit inclusions of "Roma" in the signatures of certain drawings of sites in the countryside, which indicate that, indeed, elaborate nature drawings could have been executed away from the site. This is the case of figure 3, proudly signed on the verso: "*Veduta dela villa del Sasso/lano 1649 Claudio Gillee/Rome.*" This sheet was very likely drawn in Rome, whereas the unfinished view of the Sasso village inscribed "*Claudio Loranese dal naturale*" was probably done on the spot.[19] The third factor is a small sketchbook by the artist that appeared in 1982.[20] It contains a type of very slight and occasionally inept working sketch that Claude may normally have destroyed and of which only very few were previously known. Compared with these sketches, datable to between 1645 and 1655, the bulk of his drawings appears in a new light, as definitive showpieces of painstaking execution. One of the sketchbook pages (fig. 4) shows an extended view over the Tiber valley, drawn in pen; by holding this leaflet against the light, Claude traced it through on the verso in chalk, the duct (direction of the stroke) revealing the uncomfortable position of his hand. This is the kind of notation Claude did in front of the object, which is not to say that he never made more elaborate drawings on the spot. The point to be made here is that *Panorama from the Sasso* is far removed from such working sketches.

The Sasso drawings date from the very end of the series of brilliant nature drawings Claude developed over the 1630s and 1640s. Later nature drawings are scarce. Two other drawings depict similar extended panoramas from an elevated viewpoint: *View Near Tivoli* (fig. 5), signed

on the verso *"faict Claud 1651 tivoli,"* and a large drawing on blue paper of an unidentified site (fig. 6). The view represented in figure 6 resembles that in the Chicago sheet somewhat, but is not necessarily of the same spot; in 1968, the present author suggested the early 1660s for this isolated work, but in view of the newly appeared Chicago drawing, it would seem to date as much as a decade earlier.[21]

As a rule, Claude never directly transposed his nature drawings into paintings. If a basic correspondence between his paintings and nature drawings can be felt in the years around 1640, this was no longer the case by 1650. At the time of the Chicago drawing, Claude had just completed what was his major pair of paintings up to then, *The Mill* and the *Embarkation of the Queen of Sheba*.[22] In 1649, he must have been preparing his equally large first view of Delphi (fig. 7), which he completed in 1650. It is hardly coincidental that this painting contains his finest distant view to date, a vast expanse with the rising sun crossed by that incomparable pictorial invention of a slender cloud, and on the right the stone railing of a bridge with a seated, piping shepherd. The affinity with the Chicago drawing is undeniable. Immediately following this work, Claude achieved his most heroic style in the paintings of *Parnassus*, the *Golden Calf*, and *Jacob with Laban*, all from the early 1650s.[23] Claude's largest works, they were done in the new, oblong format of the Chicago drawing. *Panorama from the Sasso* thus appears as a key work from the middle of Claude's creative life, summing up a decade of masterful study of nature and anticipating the heroic grandeur that crowns his achievement.

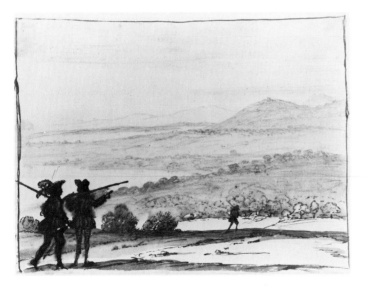

FIGURE 5 Claude Lorrain. *View Near Tivoli*, 1651. Pen and ink, chalk over wash on paper; 200 × 264 mm. Formerly, Wildenstein Album.

FIGURE 6 Claude Lorrain. *Panorama*, 1650/55. Pen and ink, brown wash, and heightening on blue paper; 236 × 401 mm. Haarlem, Teylers Museum.

One remaining point for consideration is the drawing's wider historical context, a perspective analogous to the sweeping view that unfolds in the drawing. Panoramic views of nature constitute one of the foremost types of landscapes in Dutch art. Two etchings by Rembrandt belonging to the very same years as Claude's drawing come immediately to mind: *Landscape with the Three Trees* of 1643 and *Goldweigher's Field* of 1651, which is closer to the drawing in its elongated shape and abstracted design. Also relevant in this regard is the work of Philips Koninck and occasionally of Jacob van Ruisdael. Earlier, in the 16th century, panoramic views were favored in the rendering of topographic city maps by artists like Matthäus Merian and in specific subjects such as the tempter showing Christ the riches of the world from a hilltop. The Flemish also developed wild mountain scenes and imaginary bird's-eye views.[24] Celebrated sites near Rome—especially the vista from Tivoli of the Campagna and views of the lakes Albano and Nemi—were captured in panoramas that were repeated by artists until the 19th century. Claude's *View from Tivoli* of 1645 (fig. 8), done as a souvenir for a foreign patron, is the sole example of a plunging view by the artist. In it, two shepherds converse in the foreground. But the main feature of the panorama in the Chicago drawing is its vista from a hilltop, which differs from the Dutch and Flemish prototypes cited above. The only source of inspiration that may reasonably be invoked for *Panorama from the Sasso* is Adam Elsheimer's small landscape painting and its reversed engraving by Hendrick Goudt of 1613 (fig. 9).[25] No direct formal link can be established between Elsheimer and Claude, but these works are similar in their elevated view and evocation of atmosphere and infinity.[26]

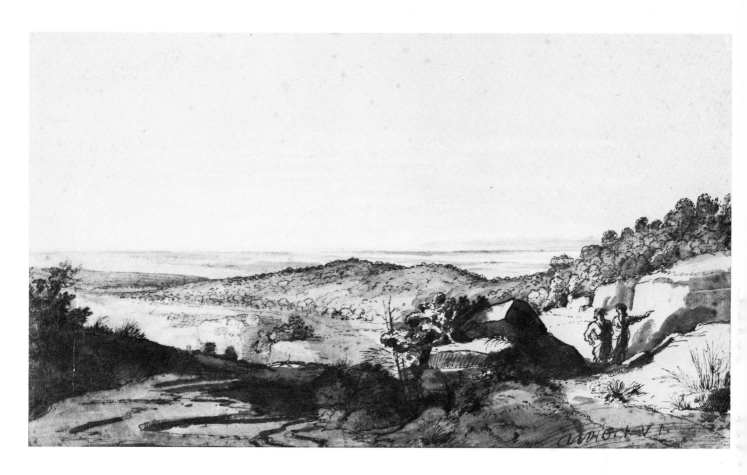

Unlike the mountain fantasies of the Flemish painters, Claude's hilltop view remained an isolated work until the end of the 18th century, when the panorama drawn from an elevated vantage point suddenly established itself as an image in all schools, flourishing until the mid-19th century. Even though Claude's drawing was not known to later artists, it stands out as a lone prototype for a genre of painting that came into its own some 150 years later. The following remarks concerning this development do not in any way attempt to offer a full typology of panoramic vistas.[27]

Oil sketches by Pierre Henri de Valenciennes, done in the 1780s mainly in Italy, contain many extended views over mountains, influenced ultimately by Claude's nature drawings.[28] Entrance into the image is often provided by means of a dark, diagonal foreground *repoussoir* on one side. During the same period, British artists, followed by the Swiss, led in a spectacular development of mountain-lore and alpine landscapes.[29] The visual artists' rediscov-

ery of the Alps was linked with the concepts of the return to nature, liberty, nationalism, and the expanding geographic concept of the world. Two other types of images evolved around 1800—views from rooftops and, more important in relation to *Panorama from the Sasso*, from terraces. At that time, the old bulwarks enclosing many European cities were replaced with terraces used for sightseeing. Some of the most popular images in this mode were the panoramic views from Richmond terrace and from Windsor, from the terraces of the parks of Saint-Cloud and Saint-Germain above the Seine, of Paris from Montmartre, of Florence from the Piazzale Michelangelo, of Naples from San Martino, of the sunrise observed from Mount Righi near Lucerne and from Taormina. The composition of one of Benjamin West's rare landscapes, a small view from Windsor, dated 1791 (fig. 10), is derived directly from that of Claude's *Expulsion of Hagar* (Munich, Alte Pinakothek).[30] West was much indebted to classical tradition and owned several drawings

109

FIGURE 7 Claude Lorrain. *Landscape with Delphi*, 1650. Oil on canvas; 150 × 200 cm. Rome, Galleria Doria-Pamphili.

FIGURE 8 Claude Lorrain. *View from Tivoli*, 1645. Oil on canvas; 93.5 × 129.5 cm. Her Majesty Queen Elizabeth II.

by Claude. Figures leaning against the wall of an esplanade and gazing into the distance became a veritable formula.[31] The landscape and figure painter Louis Gauffier, who worked chiefly in Florence, did many such views (see fig. 11). Also in this category are the topographic vignettes, created just after 1800, by the so-called Kleinmeister (small masters) such as Balthasar Dunker, Peter Birmann, and Johann Heinrich Bleuler, with their insistence on detail and pictorial framing.[32] The garden or park wall with a vista unfolding beyond it appears subsequently in the work of J. M. W. Turner (see fig. 12), François Granet, J. B. C. Corot, and many others.[33] Dating from a generation later is Edward Lear's watercolor view of Aptera in Crete, observed from a framing wall (fig. 13). In his panorama of the Mont-Blanc chain of 1818 (fig. 14), the Geneva painter Wolfgang Adam Toepffer chose as his viewpoint a hilltop with a road flanked by a stone balustrade on which two spectators are

seated. Panoramas with open sides are often found in Turner's watercolors from Italy, such as his *View of the Tiber Bending Toward Ponte Molle* from 1819,[34] and in the Italian and Greek landscapes by Carl Rottmann, such as his watercolor of *Aulis* from 1835/41.[35]

We have alluded here to the Romantic conception in which the hilltop view became expressive of a transcendental approach to nature. The main exponent of landscape as an emanation of God was the German painter Caspar David Friedrich. Among many images of this kind by him, *Morning in the Riesengebirge* (fig. 15) shares with Claude's drawing a limitless expanse viewed from a high observation point. But it differs significantly because of its explicit religious implications: the view develops from the Crucifix situated over a valley, perhaps symbolizing death, to a paradisiacal distance and a sunrise that imply resurrection. This idea was continued by the followers of Friedrich in Dresden and Scandinavia. Without its religious overtones, it is seen in an early work by the Munich painter Ernst Kaiser (fig. 16), who soon afterward turned to realism; this extended view from a hill may be a poetic evocation of the north Italian lake scenery he visited in 1828.

This picture type gained special importance for 19th-century American landscape painters. In one of his rare landscapes, dating shortly before his death in 1801, Ralph Earl attempted to render an accurate panorama from Denny Hill, near Worcester, Mass. (fig. 17);[36] he resolved the problem of the foreground and open sides by framing the large painting with two trees and by placing a connecting stripe along the bottom. Two generations later, enriched by the experience of Turner, as well as of the Americans Thomas Cole and Frederick Church, Sanford Robinson Gifford painted an infinite expanse imagined from a mountain (fig. 18); near the painting's left edge, an eagle, high above the world of man and vegetation, gazes toward the rising sun in the center and contemplates the endless space.

One of the earliest indications of European interest in landscape is a letter written by Petrarch in 1355, in which he described his pioneering ascension of Mount Ventoux in France on April 26, 1336:

You and others will experience the same I did today while ascending this mountain: the life we call blessed is placed high up and the road leading to it is narrow. . . . On the highest peak is a small platform on which we rested from our fatigues. I was struck and numbed by the unusually light air and by that grandiose spectacle. I looked around: the clouds were at my feet, and already Mounts Athos and Olympus became less incredible to me. My look turned in the direction of Italy, to which my heart is drawn most of all. I confess I sighed for that Italian sky which I discovered in my mind more than I saw it. . . . I turned around, toward the west, to

Top
FIGURE 9 Hendrick Goudt, Dutch (1585-1630), *Aurora*, 1613, after Adam Elsheimer's *Landscape at Dawn*, c. 1606. Etching and engraving; plate 167 × 187 mm. The Art Institute of Chicago, John H. Wrenn Memorial Collection (1942.270).

Bottom
FIGURE 10 Benjamin West, American (1738-1820). *View from the Terrace at Windsor*, 1791. Oil on canvas; 28 × 35.5 cm. London, The Tate Gallery.

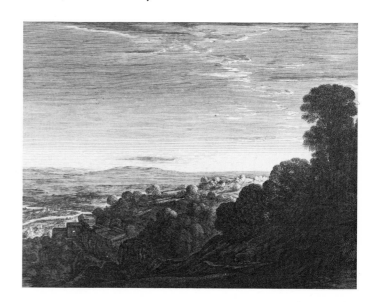

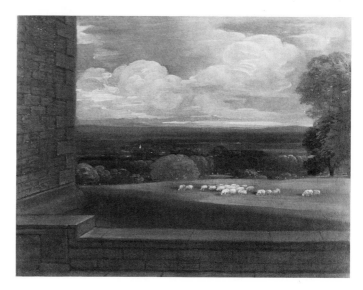

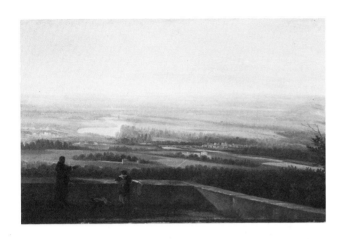

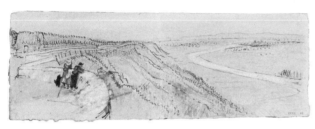

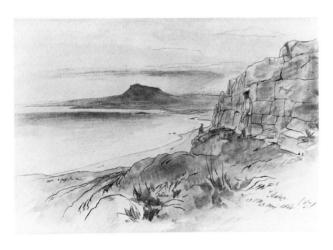

Top left
FIGURE 11 Louis Gauffier (French, 1761-1801). *Landscape*. Oil on canvas; 35 × 55 cm. Paris, private collection.

Middle left
FIGURE 12 Joseph Mallord William Turner (English, 1775-1851). *The Terrace at Saint-Germain*, 1830/31. Watercolor on paper; 9.6 × 28.1 cm. London, British Museum.

Bottom left
FIGURE 13 Edward Lear (English, 1812-1888). *View of Aptera, Crete*, 1864. Watercolor with pen and ink on paper; 29.5 × 44 cm. Athens, Gennadius Library.

Below
FIGURE 14 Wolfgang Adam Toepffer (Swiss, 1766-1847). *View from Mount Salève*, 1818. Oil on canvas; 59.5 × 97.5 cm. St. Gall, Museum. Photo: courtesy Schweizerisches Institut für Kunstwissenschaft, Zurich.

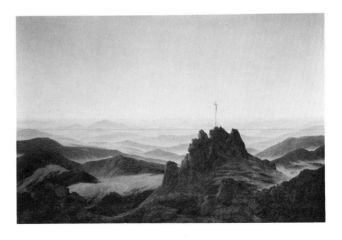

Right
FIGURE 15 Caspar David Friedrich (German, 1774-1840). *Morning in the Riesengebirge*, 1810/12. Oil on canvas; 108 × 170 cm. West Berlin, Verwaltung der Staatlichen Schlösser und Gärten, Schloss Charlottenburg. Photo: Jörg P. Anders, Berlin.

watch and admire that which I had come to see. . . . To the right appeared very neatly the mountains of the province of Lyons, to the left the sea of Marseilles, the Rhone was below us. While I admired this sight in all its aspects, now thinking of worldly matters and now elevating my spirit, I thought it appropriate to open the Confessions of Augustine, and my glance met this passage: "And man contemplates the peaks of the mountains, the wide surface of the sea, the rivers, the immensity of the ocean, the course of the stars, and he neglects himself." I was struck and outraged at the admiration I still felt for earthly things when already from the ancient philosophers I should have learned that nothing is to be admired but the soul, whose greatness is incomparable with anything else. Satisfied now by the view of this mountain, I turned the mind's eye inward. . . . How many times did I look back at the peak during my descent! And yet the height seemed to me modest compared with that of human thought. And this: If it took such effort and sweat to lift my body only a small way toward the sky, what torments can obstruct the soul in its journey to God![37]

From the Romantic period comes one of the most famous Italian poems, "The Infinite," written by Giacomo Leopardi in 1819:

This lonely hill has always been so dear
To me, and dear the hedge which hides away
The reaches of the sky. But sitting here
And wondering, I fashion in my mind
The endless spaces far beyond, the more
Than human silences, and deepest peace;
So that the heart is on the edge of fear.
And when I hear the wind come blowing through
The trees, I pit its voice against that boundless
Silence and summon up eternity,
And the dead seasons, and the present one,
Alive with all its sound. And thus it is
In this immensity my thought is drowned:
And sweet to me the foundering in this sea.[38]

For Petrarch, the survey of nature from a look-out permitted mental purification; for Leopardi, it inspired a mystical experience. While Claude's hilltop view is entirely visual, discreet, and objective, and does not call for a reading in Petrarchan, allegorical, or religious terms, it *can* admit such interpretations.

Below
FIGURE 16 Ernst Kaiser (German, 1803-1865). *Lake Scenery*, 1828/30. Oil on canvas; 38 × 74.5 cm. Private collection.

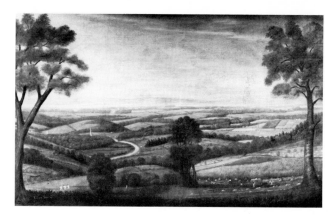

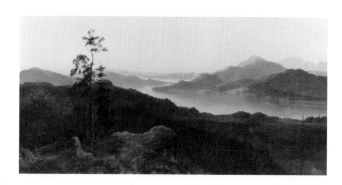

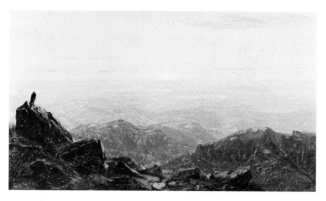

Middle right
FIGURE 17 Ralph Earl (American, 1751-1801). *Looking East from Denny Hill*, 1798/1800. Oil on canvas. Worcester Art Museum (1916.97).

Right
FIGURE 18 Sanford Robinson Gifford (American, 1823-1880). *Sunrise*, c. 1866. Oil on canvas; 16.5 × 29.2 cm. Bloomington, Indiana University Art Museum, Gift of Morton C. Bradley. Photo: courtesy Indiana University Art Museum.

NOTES

Abbreviations:

R, followed by a number: refers to Marcel Roethlisberger, *Claude Lorrain, The Drawings*, 2 vols. (Berkeley, Cal., 1968).

R. 1983: refers to Marcel Roethlisberger, *Im Licht von Claude Lorrain, Landschaftsmalerei aus drei Jahrhunderten* (Munich, 1983).

LV: refers to Claude Lorrain's *Liber Veritatis* (London, British Museum); published in full in R. 1983, *passim*, and by Michael Kitson, *Claude Lorrain: Liber Veritatis* (London, 1978).

1. "Sel pittore . . . vole delle alte cime de' monti scoprire gran campagne, e se vole dopo quelle vedere l'orizzonte del mare, egli ne signore, e se delle basse valli vol vedere gli alti monti, o delli alti monti le basse valli e spiaggie, e in effetto, ciò, ch'è nel'universo per essentia, presentia o immaginatione, esso l'ha prima nella mente, e poi nelle mani." The translation is that of the author.

2. R. 1983, no. 50; see M. Roethlisberger, "Neun Zeichnungen von Claude Lorrain," *Du* 33 (July 1973), p. 515, color ill.

3. The Art Institute of Chicago, *The Art Institute of Chicago, French Drawings of the Sixteenth and Seventeenth Centuries*, compiled by H. Joachim and S. Olsen (Chicago, 1977), nos. 1D 11, 12; 1E1, 2, 3. For the *Journey to Emmaus*, see R. 1983, no. 52, and M. Roethlisberger, in "Publications Received," *Master Drawings* 18, 2 (1980), p. 179. For the others, see also R. 396 (ships) and 1092 (copy after the *Temptation of Christ*); M. Roethlisberger, "Quelques Tableaux inédits du XVIIᵉ siècle français: Lesueur, Claude Lorrain, La Fosse," *Revue de l'Art* 11 (1971), pp. 80, 84 (copy after *Pastoral Landscape*, LV 81); and idem, "Drawings Around Claude, Part Two: Drawings by Angeluccio," *Master Drawings* 4, 4 (1966), p. 383 (foliage by Angeluccio).

4. M. Roethlisberger, "Neun Zeichnungen von Claude Lorrain" (note 2), p. 516, ill. slightly larger than life size. The black frame line was arbitrarily completed by the publisher along the left and right sides.

5. Washington, D.C., National Gallery of Art, and Paris, Réunion des Musées Nationaux, *Claude Lorrain 1600–1682*, exh. cat. by Diane Russell (1982), no. 40.

6. Claude's late painting, *View of Delphi with a Procession* (LV 182), in the Art Institute is an unfortunate case in point.

7. Only three other drawings, entirely different in type, have this format: R. 76, 352, and 952.

8. The site is described in A. Belli, *Diporti e riposi villerecci* (Rome, 1851), p. 23; and G. Tomassetti, *La Campagna romana* (Rome, 1910), vol. 2, p. 542, which includes a photograph of the village's baronial palace from the southwest.

9. Discussed under R. 1983, no. 49; and in M. Roethlisberger, "A New Drawing by Claude and the Problem of the Modifica-tion of Nature," in *Scritti di storia dell'arte in onore di Federico Zeri* (Milan, 1984), p. 623.

10. R. 671.

11. Washington, D.C., National Gallery of Art (note 5).

12. Affinities between Claude's art and Chinese landscapes have occasionally been noted, for example, in connection with a drawing in Oxford (see R. 357). Claude was very likely familiar with Chinese paintings, which were imported by Jesuit missionaries and circulated widely in Rome. One of the most learned Jesuits in Rome at the time, the German Athanasius Kircher, published a very lavish book on Chinese painting (*China Monumentis* [Amsterdam, 1667; French ed. 1670]), whereupon J. von Sandrart immediately included a chapter on it in his *Teutsche Akademie*, pt.1 (Nuremberg, 1675). However, no specific link between Claude and Chinese paintings can be shown to exist. The Chinese landscapes mostly include prominent vertical peaks. See also P. Conisbee, "Pre-romantic *plein-air* painting," *Art History* 2 (1979), p. 413.

13. F. Baldinucci, in M. Roethlisberger, *Claude Lorrain, The Paintings* (New Haven, 1961), vol. 1, p. 62.

14. Von Sandrart (note 12), pt. 2, p. 332. It is very odd that no paintings exist by Claude that were clearly done out-of-doors, with the possible exception of LV 15.

15. Diane Russell's discussion of Claude and music (note 5, pp. 91–93) is, in this author's opinion, unconvincing.

16. The view of Santa Marinella is LV 46; the castle of Santa Severa recurs in Claude's seaport composition with Saint Ursula, LV 54.

17. R. 670. A photograph of these two cliffs is included in Tomassetti (note 8), p. 544. Long before the Villa del Sasso was built, a now-ruined castle existed on the two cliffs.

18. R. 622, 623v, and 671.

19. The unfinished view is R. 623v. This drawing, however, poses a problem: its inscription is on a strip of paper that was glued onto the drawing by the artist himself, an operation that was surely not carried out in the field. For more details about the wording of the signatures, see Roethlisberger (note 9).

20. Sale, London, Sotheby, Nov. 18, 1982, lot 43. See P. Bjurström, *Claude Lorrain Sketchbook* (Stockholm, 1984). Figure 4 is discussed on pp. 31–33. Bjurström rightly rejected several of the loose sheets that M. Kitson ("A Small Sketchbook by Claude," *Burlington Magazine* 124, 956 [1982], p. 698) admitted as being by Claude as well. Several of these sheets are, in this author's opinion, by Francesco Allegrini.

21. Further links with some of Claude's drawings can also be mentioned. The lateral opening occurs, though hardly ever as radically as in the Chicago drawing, in several sheets around 1640 where topography was of special concern. Examples are R. 288 (*Lake of Bracciano*), 289 and 310–15 (*Views of Civitavecchia*), 353 and 425 (*Tiber Valley*), and the drawing entitled *Coastal View of Santa Marinella* (see *L'Oeil* 226 [May 1974],

p. 34, pl. 6). At that time, Claude rapidly outlined several extremely elongated panoramas. These are the top of sheets R. 276 (*View from Velletri*), 404, and 406v (the upper sketch of which might just possibly be another view from the Sasso, comparable to R. 670). The motif of the parapet, while less dominant than in the Chicago drawing, is found in paintings LV 70 and 179 and in the related drawing R. 680.

22. LV 113, 114.

23. These, respectively, are LV 126, 129, 134.

24. In this regard can be mentioned works by Pieter Brueghel, Hieronymus Cock, Hendrick van Cleve, Joos de Momper, Lucas van Valckenborch, and others. Also relevant are famous drawings showing plunging mountain vistas from around 1600 by Roeland Savery (Paris, Musée du Louvre), and Jacob de Gheyn the Younger (London, Victoria and Albert Museum, and New York, Pierpont Morgan Library).

25. The small painting on copper, datable to about 1606, is in Braunschweig, Herzog Anton Ulrich-Museum. It also influenced Rembrandt and Hercules Seghers.

26. It is no surprise that we are led to this German artist, who died in Rome in 1610 at a young age. His influence was strongly felt by the northern landscapists of the next generation: Pynas, Poelenburgh, Breenbergh, Wals, as well as the young Claude and the Italian Filippo Napoletano.

27. The literature on this subject is inadequate. Recent books on panoramas deal with large-scale topographic imagery, which forms a picture-type of its own.

28. R. 1983, nos. 150–52. About 100 such works by Valenciennes are in the Musée du Louvre, Paris (see Paris, Musée du Louvre, *Musée National du Louvre, Peintures, Ecole française, XIX^e siècle*, cat. by C. Sterling and H. Adhémar [1961]).

29. See M. Roethlisberger, *The Alps in Swiss Painting* (Chur, Switz., 1977); and N. Rasmo, M. Roethlisberger, et al, *Die Alpen in der Malerei* (Rosenheim, 1981).

30. A monumental stone railing extending across the entire picture also occurs in Claude's lost masterpiece, the painting of Esther (LV 146).

31. The distance may be hidden from the viewer of the painting, in which case the staging resembles the common theatrical (and ultimately Homeric) device of a player describing a remote action observed from his vantage point ("Mauerschau"). By the third quarter of the 19th century, the Impressionists developed—mainly at Etretat—a type of image of a foreground cliff from which figures look out toward the sea (see, for example, Pierre Outin's painting of a cliff where a woman scrutinizes the distance with a telescope; sale, London, Sotheby, June 21, 1983, ill.; or Claude Monet's *Cliffs at Pourville* in the Art Institute [1933.443]).

32. P. Kopp, B. Trachsler, and N. Flüeler, *Malerische Reisen durch die schöne alte Schweiz* (Zurich, 1982); see, for example, Bleuler's 1815 view of Lausanne from a terrace.

33. Examples include R.P. Bonington's *View of Marly from Saint-Germain* of 1823, Turner's 1826 oil *View from a Terrace on the Isle of Wight* (Boston, W. Coolidge Collection), and Corot's 1834 paintings of *Genoa* and the *Boboli Gardens* (see A. Robaut, *L'Oeuvre de Corot* [Paris, 1905], nos. 300, 309) and of the *Villa d'Este* of 1843 (Paris, Musée du Louvre).

34. G. Wilkinson, *Turner Sketches 1802–20* (London and New York, 1974), p. 187; and Hamburg, Kunsthalle, *William Turner und die Landschaft seiner Zeit*, exh. cat., essay by Werner Hofmann (1976), no. 45.

35. E. Bierhaus-Rödiger, *Carl Rottmann* (Munich, 1978), no. 624, ill.

36. L. Goodrich, *Ralph Earl* (New York, 1976), fig. 41.

37. The Latin text, translated by the author, has been slightly contracted.

38. Sempre caro mi fu quest'ermo colle,
E questa siepe, che da tanta parte
Dell'ultimo orizzonte il guardo esclude.
Ma sedendo e mirando, interminati
Spazi di là da quella, e sovrumani
Silenzi, e profondissima quiete
Io nel pensier mi fingo; ove per poco
Il cor non si spaura. E come il vento
Odo stormir tra queste piante, io quello
Infinito silenzio a questa voce
Vo comparando: e mi sovvien l'eterno,
E le morte stagioni, e la presente
E viva, e il suon di lei. Così tra questa
Immensità s'annega il pensier mio:
E il naufragar m'è dolce in questo mare.

A Leopardi Reader, ed. and trans. by Ottavio M. Casale (Urbana, Chicago, London, 1981), p. 44.

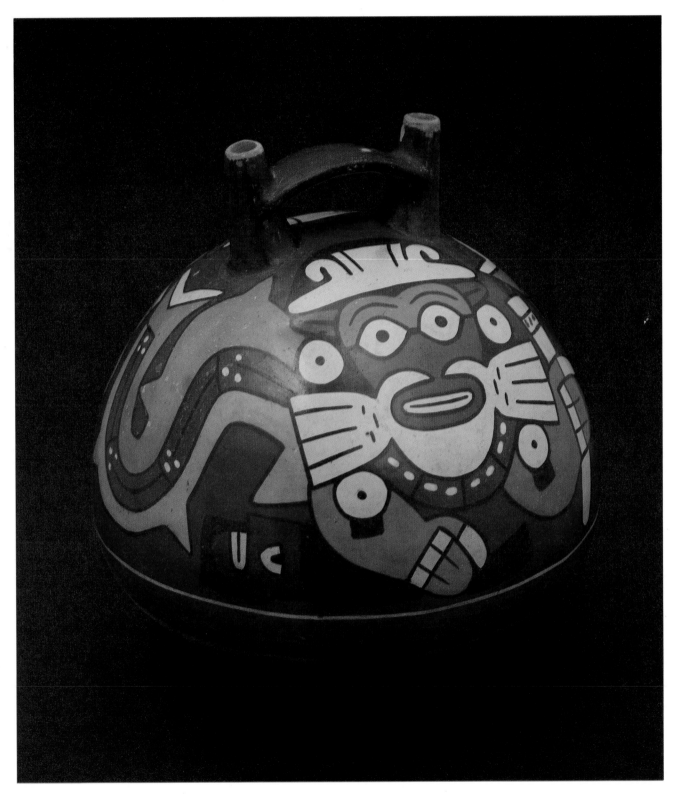

116

Deciphering the Nazca World: Ceramic Images from Ancient Peru

RICHARD F. TOWNSEND, *Curator,*
Africa, Oceania, and the Americas

*T*HE COASTAL river valleys and high mountain basins of Peru were the setting for a succession of cultures that formed one of the New World's most splendid and diverse civilizations, rivaled only by that of ancient Mexico and northern Central America. Travelers who visit the archeological sites of the region are offered glimpses of this ancient cultural and artistic heritage in the spectacular ruins of Machu Picchu, the megalithic walls of Cuzco, and other well-known ruins of the Inca empire. Conquered in 1532 by the Spanish expedition of Francisco Pizarro, the Inca state encompassed a vast section of western South America, along the great Andean mountain chain from Ecuador in the north to the Bolivian plateau and Chile in the south. But, the empire itself was new and still politically unstable, having been formed only during the fifteenth century. Like the Romans, who adopted much from the earlier Hellenistic world and older kingdoms of the Mediterranean and Middle East, the Inca had incorporated ideas, institutions, and symbolic forms from a complex civilization of much greater age. The depth of this cultural heritage is beginning to be known as archeological explorations slowly reveal thousands of years of Andean culture, from remote Ice-Age migrations, the early establishment of coastal fishing settlements and the appearance of agriculture, to the gradual development of cities and elaborate state organizations. Archeological evidence shows that the evolution of this civilization was marked by the interaction of many peoples and by the rise and fall of a succession of regional capitals, states, and extensive empires.

In keeping with this political and ethnic diversity, ancient Andean art displays a broad range of visual languages, with great variety of materials, styles, and themes. The brilliant textiles, precious metals, ceramics, and monumental archi-

Facing page
PLATE 1 *Globular jar with pictogram*, c. 115/55 B.C. Earthenware with colored slips; h. 18.57 cm. (1955.2100). Photo: Kathleen Culbert Aguilar, Chicago.

The dating of these vessels is still imprecise: dates given here are approximate. Traditionally, vessels are assigned phase numbers in archeological reports, but they have been deleted here. Unless otherwise noted, all vessels illustrated are from the Nazca culture; are in The Art Institute of Chicago; are of earthenware with colored slips; and have been photographed by Kathleen Culbert Aguilar, Chicago.

117

tecture produced over many centuries form one of the world's most lively and powerful artistic traditions. Because these arts were manufactured by societies whose intellectual and spiritual life was unaccompanied by writing, their forms fulfilled a basic role in communicating essential cultural information, along with ceremonial dance and orally transmitted poetry and song. Works of art formed part of a set of complex symbolic codes that were easily recognizable to the knowledgeable members of society. The ancient arts of Peru thus are not only meaningful for their sophisticated designs, technical refinement, and expressive qualities, but also because they record historical processes and offer windows to other orders of thought—to ancient ways of looking at the world that are deeply rooted in the cultural traditions of this hemisphere and that continue to affect the lives of millions in Andean nations today.

The Art Institute of Chicago is fortunate in possessing an outstanding collection of Peruvian ceramics, including examples from most of the notable styles of a two thousand-year period, extending from the middle of the first millennium B.C. to the Spanish conquest in the sixteenth century. The ensemble comprises parts of the former Wassermann-San Blas/Nathan Cummings and Hans Gaffron collections acquired by the Art Institute during the late 1950s and early 1960s. Masterpieces from these collections were featured in early books published on ancient Peruvian art, and in Alan Sawyer's well-known *Ancient Peruvian Ceramics*, written when he was the Art Institute's first Curator of Primitive Art.[1] A selection of the finest works in the museum are now on permanent display in the new galleries of the Department of Africa, Oceania, and the Americas. Among the many vessels on view, the group of Nazca ceramics presents an especially striking display of subtle geometric shapes, warm earth colors, and bold surface designs with both representational and abstract imagery. Made in the South Coast region between about 180 B.C. and A.D. 500, Nazca ceramics are widely recognized as one of the most visually appealing and culturally informative Peruvian traditions. Yet they also remain one of the most enigmatic, for studies of Nazca ceramic imagery are only beginning to approach an interpretive phase. Here, we shall look at Nazca vessels as part of a larger symbolic system. The ideas and images encoded by these forms belong to a distinctive culture in a somewhat isolated region, yet they also express themes that have broader implications concerning art and thought in the evolution of Andean civilization.

Approaches to Nazca Art

Nazca artists created a range of vessels that includes spheres, domelike jars, open bowls, cylinders, and figural shapes. Characteristically, closed containers are surmounted by twin spouts bridged by a flat, straplike clay handle. In general, these vessels tend to have simple shapes without modeling, but the smooth, delicately curving surfaces are highly burnished and painted with a great diversity of images. The painted subjects are depicted in flat areas of color, usually bounded by lines, with no attempt to represent volume or depth. If volume was to be shown, it was achieved by using the shape of the vessel itself. With few exceptions, lines are restricted to describing the limit of color areas, and they do not have a separate, expressive life of their own. A rich palette of hues also characterizes Nazca ceramics: as many as twelve colors have been counted, more than in any other New World pottery tradition. Clay slips colored with mineral agents were painted on the terracotta vessel and fired in an oxidation atmosphere to produce colors ranging from deep Indian red, pink, orange, and ocher to violet, slate blue, and black and white.

It is clear that Nazca artists based their imagery on things seen and experienced in the world around them. It was the task of the ceramicist to represent selected features of their environment in figures that are more or less abstract but clearly recognizable (see pl. 2). At the same time, they created composite forms of elements separated from their original natural contexts and reassembled in new, abstract ways (see pl. 1). As we shall see, it is likely that such composite images were pictograms, representing concepts, ideas, or figures of speech. Still another category comprises masked beings with elaborate headdresses and other symbolic objects that refer directly to the religious and economic life of the Nazca region (see pl. 7).

By all accounts, this art describes a time, place, and culture far removed from the urban, technological world that most of us inhabit. Without written texts to help interpretation, it might seem impossible to bridge the gap between ourselves and that distant setting. There is nothing akin to the Rosetta Stone of ancient Egypt to give us the key to deciphering the meaning of these forms, nor is there a body of scriptures, as in Christian art, to explain symbolic figures. Indeed, we do not even know what language was spoken by the Nazca population. We may imagine, however, that the land, its animals, and its plants formed a storehouse not only of economic resources, but also of knowledge, expressed in stories, metaphors, and aphorisms rich in meanings and associations. In this respect, the environment served as a kind of school, providing a background of common empirical knowledge and cultural values. Among the farming people of Nazca towns, where education was not a matter of marked specialization or scholastic privilege, much of the traditional information shared by the community was transmitted as part of normal exchanges between individuals and between households. On festival occasions such as rites of passage or ceremonies of the agricultural cycle, such shared knowledge would be visibly expressed in song, dance, and costumed performances. The problem of approaching the world portrayed by Nazca art is one inherent in the investigation of many prehistoric or tribal arts and must be answered by marshaling clues and evidence from several related disciplines: studies of the natural setting, archeology, the history of art, and ethnology.

Reports on Nazca ceramics have appeared intermittently since the early decades of this century, and several of these form the point of departure for our present inquiry. Based upon archeological information from different sites and on a selection of vessels from the Wassermann-San Blas/Nathan Cummings and Hans Gaffron collections, Alan Sawyer established an outline of changes of style in Nazca ceramics. Elaborating on these observations and citing examples from other important collections, Donald Proulx later presented a more detailed discussion of the distribution of vessel types and their designs within the Nazca region, indicating the development of local styles at different times and places.[2] Numerous other scholars have identified and listed many of the subjects depicted in the Nazca repertory, such as birds, animals, and plants, as well as composite forms and human types and their activities.[3]

All of these reports make reasonably clear that, despite the diversity of forms, the appearance of local styles, and shifts in the development of new shapes and designs, Nazca ceramics show no major influence from other Peruvian peoples or radical innovations from within the tradition. Although certain subjects are emphasized at different times, the fundamental inventory of subjects remains relatively constant. The overall impression is one of a stable, conservative art, the expression of an isolated culture that did not experience outside conquest or intervention. But our knowledge of the chronology, styles, and categories of

PLATE 2 *Irregular globular jar with lizards*, c. 25 B.C./A.D. 65 (?). H. c. 16.5 cm. (1955.2096).

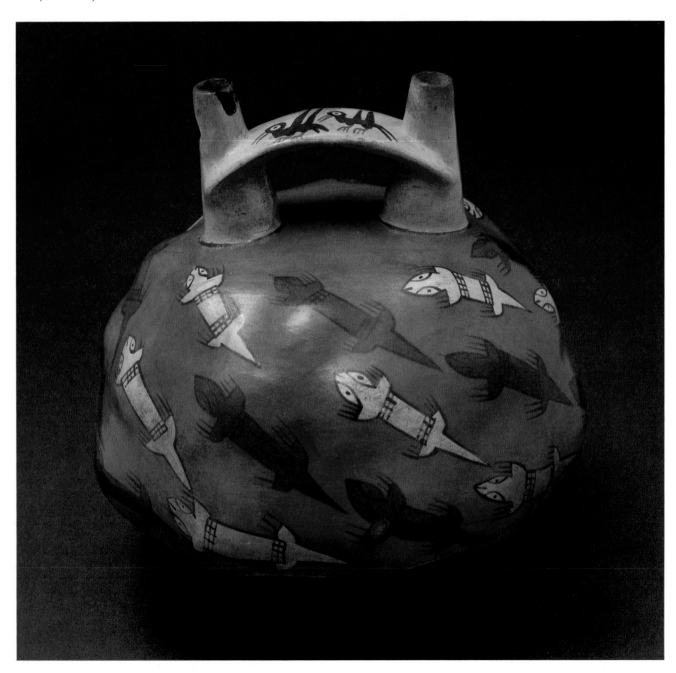

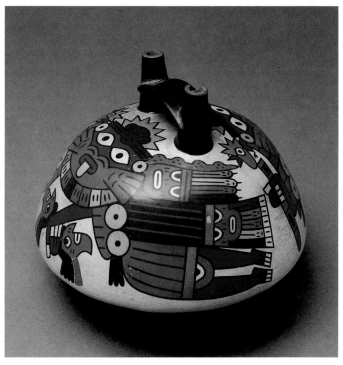

PLATE 3 *Dome-shaped jar with ritual performers*, c. 25 B.C./A.D. 65. H. 14.12 cm. (1955.2128).

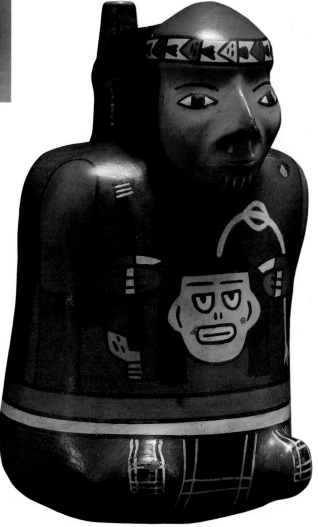

PLATE 4 *Warrior effigy with dart thrower and trophy heads*, c. 25 B.C./A.D. 65. H. 17.93 cm. (1955.2162).

FIGURE 1 Map of western South
America from Colombia to
Chile.

- Cities
▲ Archeological zones
▨ The Andes

subjects portrayed by Nazca artists does not explain the way in which the different subjects may be interconnected or the order of thought they represent. How was the relationship between plants, animals, and human activity reflected in the imagery of ritual? What outlook on the world surrounded the creation of these figures? What are their underlying messages and meanings? In attempting to answer these questions, we shall see that the ceramics form a code, a cohesive "text" of signs and symbols; when deciphered, the "text" of this pictorial language reveals that the Nazca, like other Indian peoples of the Americas, believed that there was an active, sacred relationship between man and nature. According to this mode of thought, the divine order of the universe was reflected in the organization of society and in all important activities of human life. Thus, the control of water, planting of fields, harvesting of crops, preparations and celebrations of war, inauguration of rulers, and similar communal events had symbolic meaning and were bound, in a ramifying network of connections, to the forces and phenomena of the surrounding land and sky. This connection of cosmological ideas and social processes is a central point of inquiry in approaching the Nazca world.

Landscape and Symbol

Since a large body of the subjects represented on the vessels portrays things seen in the natural setting, an important step in understanding that world is to look at the physical features of the Nazca region and its outstanding archeological monuments. The landscapes of Peru lead inward from the sea in a dramatic sequence of natural environments, from barren coastal deserts to rockbound foothills and the awesome Andean escarpments (see fig. 1). The Continental Divide runs the length of the great cordillera (chain of mountains): the greater part of the water generated by the mountains drains eastward into the vast aquatic network of the Amazon while the Pacific strip west of the Andes receives practically no rainfall. The South Coast inhabited by the Nazca is one of the world's most forbidding deserts, but two features of this seemingly inhospitable land made urbanism possible. The first is the sea, where vast schools of sardines and other fish thrive in the cold, plankton-rich waters of the Peru current. This abundant source of protein permitted the establishment of settlements and towns well before the appearance of agriculture about 7,000 B.C. The second natural feature is the series of small rivers threading down from distant Andean sources to join the main course of the Rio Grande de Nazca, and, some thirty to fifty kilometers to the north, the Rio Ica. Even though these rivers do not flow for several months of the year and have been known to remain dry for several years in a row, towns have long been established along their banks. In order to supplement the surface supply, systems of underground canals were tunneled to capture and channel existing ground water for irrigation. Even so, then, as now, farming remained ultimately dependent upon seasonal rains generated on the distant Andean peaks. The water supplied by these rains, filtering down through the Nazca valleys, was critical to human survival.

The border between the desert and the sown land in the South Coast river valleys is as sharply defined as in Egypt or Mesopotamia. The sere terrain beyond the green area of cultivation is the place of ancient cemeteries, where well-preserved tombs have yielded huge quantities of pottery and textiles. But little supervised scientific archeology has been done, and the majority of these objects has been recovered by pot hunters (*huaqueros*) from nearby villages who mine

the old burial grounds. The earliest forms of Nazca ceramics spread rapidly around 200 B.C., supplanting local native forms at a succession of places in the Nazca drainage and, soon thereafter, in the neighboring Rio Ica valley. This has been interpreted as evidence of a military, religious, and economic domination that branched out from such major sites as Cahuachi, on the Rio Grande de Nazca, long regarded as the largest ancient civic and religious center. Since September 1984, a new program of archeological excavation has been underway at this major site.[4]

In addition to such urban remains, the region contains one of the most unique and mysterious archeological features of South America, the famous Nazca lines (see figs. 2, 3). These form immense networks of lines, spirals, radial patterns, stripes, and representational figures drawn upon the arid plateaus above the river valleys, especially between the Rio Grande de Nazca and the smaller Ingenio and Palpa rivers, as well as in scattered places along the Andean foothills. The lines were made by removing the darkly weathered surface stones to expose the underlying lighter sand and gravel. Dated to the period corresponding to the manufacture of Nazca ceramics, their meaning has been much debated.[5] It has been speculated that they functioned as lines for astronomical sightings and as processional ways; and, on a more imaginary level, they have even been interpreted as landing-strips for prehistoric astronauts from outer space and as evidence that the Nazca invented large hot-air balloons from which to look down upon the designs from the sky! Writing twenty years ago, art-historian George Kubler remarked that the lines might be called a kind of architecture:

> They are clearly monumental, serving as an immobile reminder that an important activity once occurred. They inscribe human activity upon the hostile wastes of nature, in a graphic record of what was once an important ritual. They are an architecture of two-dimensional space, consecrated to human actions rather than to shelter, and record a correspondence between the earth and the universe, as at Teotihuacan and Moche, but without their corresponding masses. They are an architecture of diagram and relation, but with the substance reduced to a minimum.[6]

Underlying all serious investigation of their function is the notion that the lines represent a correspondence between society and nature. Archeoastronomers have reported that environmental cycles along the Peruvian coast, such as the local periods of abundant water, the best fishing, or the brief appearance of vegetation in mist-bound foothills of the Andes, formed part of more elaborate regional calendars; and that these calendars were keyed to celestial phenomena that rose, set, or stood at zenith during critical "boundary" times in the seasonal cycles. It is beginning to appear that ceremonial structures such as pyramids and plazas were oriented to such celestial events along the Peruvian coast, and studies are now being conducted to show that certain Nazca lines obeyed such astronomical alignments.[7]

In addition to these inquiries, another recent and convincing study by Johan Reinhardt has shown that many, perhaps the majority, of the Nazca lines are primarily linked to the worship of mountains, water, and fertility.[8] Mountain worship was, and still is, fundamental to native Andean religions, and must have been so in ancient Nazca times as well. Mountains today are regarded as the lords of extensive domains and guardian deities of wildlife, with special powers governing fertility and regeneration. In this respect, mountains are also worshipped as the home of rain gods, from whom different peoples trace descent. Rain clouds form upon mountains; therefore, in terms of ecology, mountains are indeed sources of life in the Andean world. Reinhardt has presented evidence that certain hills in the Nazca area continue to be worshipped, although they

Top
FIGURE 2 Aerial view of Nazca lines on the desert plateau above the Palpa and Ingenio rivers. Photo: George Kubler, *The Art and Architecture of Ancient America* (Baltimore, 1962), pl. 143.

Bottom
FIGURE 3 Aerial view of Nazca lines showing a hummingbird figure. Photo: Dr. Robert Feldman, Field Museum of Natural History, Chicago.

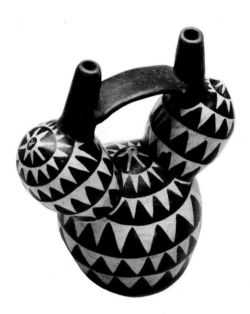

FIGURE 4 Achira *root vessel,*
c. 175/25 B.C. H. 17.48 cm.
(1955.2083).

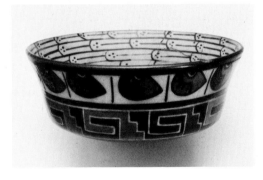

FIGURE 5 *Flared bowl with beans,
geometric motifs, and fine-line bas-
ketry pattern,* c. 55/25 B.C. H. 7.62
cm. (1955.1886).

may be dry and covered with sand and rock. Although such knolls and outcrop-
pings are far from the cloud-shrouded Andean heights, they are local, topo-
graphic icons of those distant mother-mountains. For Reinhardt, a majority of
the lines and figures on the desert establish connections with mountains, as
direct pathways, as links between related heights, or as identifying signs associ-
ated with real or symbolic sources of water.

This interpretation of the Nazca lines is consistent with recent findings at a
series of major archeological ruins in the mountainous regions of central Mexico.
At the fifteenth-century religious and civic centers of Tenochtitlan and Tetz-
cotzingo, at sixth-century Teotihuacan, and at Chalcatzingo, which dates from
about 500 B.C., there is conclusive evidence that pyramids, temples, and related
sculptures were physically and symbolically bound to the local topographic
setting.[9] These major ritual centers functioned as symbolic landscapes where
architectural shapes and effigies of nature-gods mirrored the mountains, clouds,
caves, rivers, and agricultural products of the surrounding region. Such findings
point to an underlying level of ancient Amerindian religion that has not been
systematically reported or explained before. The evidence reveals an animistic
perception of the world that was tied to the familiar features of local landscapes;
an archaic vision that maintained that certain forms and forces were sacred, part
of processes in nature that had important correspondences with the sphere of
man. In this system of correspondences, earth and water, animals and plants, and
the changing cycles of the seasons were part of a cosmic pattern that included the
organization of society and all important individual and community activities.
Humankind was not passive or dependent, and by carrying out the appropriate
religious activity and conducting life in accordance with the order of the natural
cycle, man played an active, helpful, and necessary role in the cosmic system.
This manner of perceiving the sphere of man as embedded and participating in
the processes of nature is profoundly different from the pattern of western,
Judeo-Christian thought, which places humankind in a dominant position,
closer to a transcendent God than other forms of life in the hierarchy of creation.

Although Peru had no direct historical link with Mexico in antiquity, and
ethnographic information concerning mountain worship among modern An-
dean Indians describes beliefs and practices some 2,000 years after the time of
Nazca culture, there is reason to suppose that the design and functions of the
Nazca lines were informed by a matrix of related, deeply-rooted notions con-
cerning sacred geography; and that this way of affirming the connections be-
tween man and nature also forms the basis for approaching Nazca ceramic art.
Contained within an isolated geographic region, the Nazca communities appear
to have required an art of restricted themes, principally reflecting their agri-
cultural economy and internal military competition. We do not find portrayals of
individuals, no scenes that we might interpret as specific historical events, no
subjects of a domestic nature. There is no ready explanation for the restricted
range of human subjects in this ceramic tradition, which contrasts with the
diversity of activities seen in the art of the powerful Moche empire located in
Peru's North Coast. There, ceramics include extraordinarily naturalistic por-
trayals of individuals, various economic activities and types of occupations, as
well as domestic scenes (including a range of erotic activities) and historical or
religious events with well-established episodes. The art of the North Coast,
often highly sculptural, is one of a cosmopolitan society. Yet, the art of the South
Coast river valleys also summons a lively world, and it would be erroneous to
think of it in terms of simple economic or utilitarian themes. As we shall see, this
was also a highly structured tradition with a rich interplay of meanings, illustrat-
ing processes and the relationships of things in time and space.

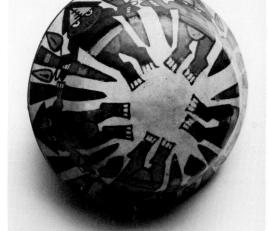

FIGURE 6 *Shallow flared bowl with farmers*, c. 25 B.C./A.D. 65. H. 6.2 cm. (1955.1940).

Fruits of the Earth

By the time the Nazca inhabited the South Coast river valleys, agriculture had become the primary economic base, supplemented by the rich fisheries of coastal waters. The population raised a variety of staple plants, and these fruits of the earth were an important part of the Nazca pictorial vocabulary. An especially appealing vessel in the Art Institute collection represents an *achira* root, one of several starchy cultigens that are still among the basic items of the regional diet (see fig. 4). The modeled shape combines bulbous, swelling forms with a strong surface design of black-and-white serrated lines, while the strap handle and twin spouts are colored a deep Indian red. Another exceptionally fine bowl (fig. 5) shows a highly stylized row of beans painted around the outer rim, while the inside presents coiled basketry drawn with unusually fine lines.

The representation of cultivated plants is often closely tied to depictions of agricultural ceremonies in Nazca art. In the South Coast river valleys, farmers were protagonists in these activities, as shown by the design on a charming bowl in the collection (fig. 6). The composition features five persons engaged in a dance celebrating the first-fruits or the later harvest season. As was customary, human figures are rendered with an almost caricaturelike brevity, and little attention is given to accurate anatomical proportion or detail. Articles of clothing and the objects they hold are meticulously drawn, for they are attributes indicating the position and function of each person in society. A farmer, for example, is always represented wearing a conical hat sewn up the front, a short tunic, and a breechcloth. He also carries agricultural implements, principally a digging stick. In celebration of the harvest, the figures on the bowl also brandish vegetables—beans, peppers, and the cucumberlike fruit known locally as *lúcuma*.

FIGURE 7 *Shallow flared bowl with first-fruits or harvest ritual performer, c. 25 B.C./A.D. 65. H. 10.8 cm. (1955.1929).*

Another, more elaborate representation of agricultural ceremony is seen on a flared cup (fig. 7). The subject again wears the emblematic farmer's hat, but in this case the rest of his complex attire has been especially designed to display the earth's abundance. His face is brightly daubed with red and black dots, he wears painted gourds as ear ornaments, and holds peppers, *lúcuma*, and beanpods high in either hand. His great semicircular collar is bedecked with peppers, and his crossbelt is hung about with *jíquima* (an edible cultivated root now no longer raised) and another root staple, the starchy *yuca* still widely consumed in all Andean countries. Ears of multicolored corn are bound around the performer's waist, and below, between his lower legs and feet, is a great pepper, a humorous reference to a penis and fertility. Seeds are depicted scattered on the ground and in the air. There can be little doubt that the artist who ingeniously wrapped this colorful figure around the simple shape of the flared cup intended to represent a costumed figure such as those who appeared in the public plazas, and perhaps also in agricultural fields, to celebrate the great annual feasts of the Nazca region.

Animals

Nazca ceramic imagery reveals that animals, like plants, formed an important component of the Nazca world view. A broad range of zoological forms were modeled and painted in an equally broad range of styles at different times and places. Each creature depicted had an important property or associational value. Some animals, such as fish, had a practical, utilitarian importance as a source of food; others, especially certain birds, reptiles, and insects, may have had practical use, but they were also symbolically important as reminders of seasonal events. The work of the Russian-émigré naturalist Eugenio Yacovleff was fundamental in deciphering this realm of Nazca art, for he was the first to systematically pursue the identification of the natural species represented on the vessels.[10]

The swallowlike *vencejo*, a bird with black feathers, white collar markings, and hairlike whiskers around the beak, frequently appears in the Nazca cast of characters (see fig. 8). Yacovleff observed that these birds are most visible in times of high humidity, when the rivers flow in response to the onset of the rainy season in higher mountain elevations. The increase of moisture also coincides with the resurgence of insects, upon which the *vencejo* feeds. This bird thus heralded the beginning of the agricultural season, and Yacovleff speculated that its appearance may also have been interpreted by the villagers as an augury of good crops.

Hummingbirds, too, are often represented on Nazca vessels (see fig. 9), sometimes in the act of feeding on flowers, probably an indication of their relationship to agriculture. These birds were also highly prized for their irides-

cent feathers, which were woven by skilled women into shimmering garments worn by members of the Nazca aristocracy. Similarly, the appearance of parrots on Nazca ceramics may be explained by their brilliant feathers, as well as by their ability to imitate speech (see fig. 10). Parrots were not indigenous to the region but were imported over the sierras from the Amazon basin. Sea birds of various kinds form yet another major category of Nazca avian imagery (see fig. 11): they aided the fisherman, for the pattern of their flights and sudden dives into the sea revealed the location of schools of fish beneath the surface.

Foxes are among the most widely distributed animals of the Peruvian desert coast, and Nazca painters from all periods commonly represented them on their vessels. On one of the most visually poetic jars in the known body of Nazca ceramics, foxes are depicted among desert cacti, reptiles, and sinuous, mythic creatures (see pl. 5). We shall return to this remarkable pot at a later point, but we may pause here to note how the foxes were represented in profile, with their most distinctive features—long, whiskered snouts; bared teeth; pointed ears; white fur along the belly; and full, bushy tails—caricatured by deliberate exaggeration as in so many other instances in Nazca art.

Above left
FIGURE 8 *Shallow bowl with* vencejo, c. 115/55 B.C. H. 6.99 cm. (1955.1870).

Above right
FIGURE 9 *Shallow bowl with hummingbirds and beans*, c. 115/55 B.C. H. 5.23 cm. (1955.1860).

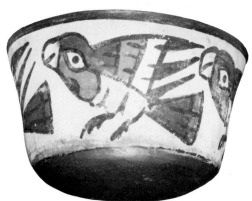

FIGURE 11 *Sea bird and fish* (drawing), after a dual-spout globular jar, c. 145/115 B.C. (1955.2090).

FIGURE 10 *Shallow bowl with parrots*, 145/115 B.C. H. 5.56 cm. On loan to The Art Institute of Chicago from the Hans and Mercedes Gaffron Collection, Chicago.

127

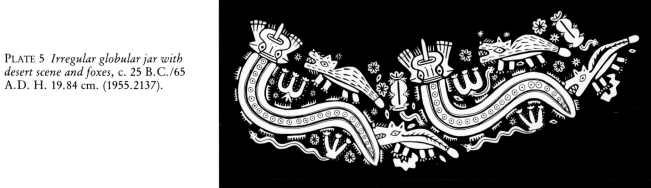

PLATE 5 *Irregular globular jar with desert scene and foxes*, c. 25 B.C./65 A.D. H. 19.84 cm. (1955.2137).

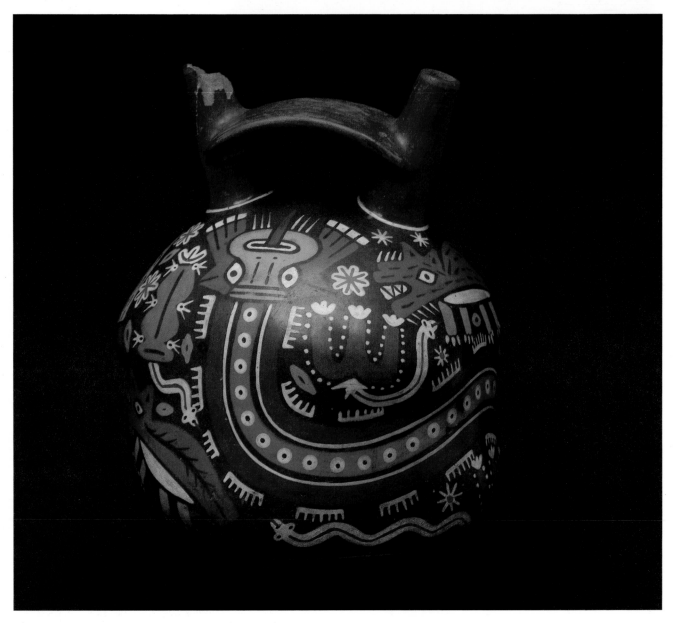

Another frequently depicted land predator exhibits feline characteristics, with spotted and banded gray, white, and black fur, short round ears, whiskers, and a round face with a small nose and large eyes. An example in the Art Institute collection represents this engaging beast (fig. 12). The vessel comes from the early period of Nazca ceramics, when lines were still engraved into the surface rather than painted. There has been some controversy concerning the identification of these animals, and it has been said that they really represent stylized foxes or otters,[11] but our example can hardly be taken for a member of the canine species. It is surely *Felis (Lynchailurus) colocolo*,[12] whose range in antiquity certainly included the Nazca drainage. Throughout the Andean world and elsewhere in the Americas, felines were—and still are—highly esteemed not only for their handsome pelts but also for their abilities as hunters. *Felis colocolo*, not much bigger than a house cat, commonly patrols fields in search of rodents and related pests that endanger crops: in this respect, they were important in controlling these damaging populations.

That mice were indeed feared in ancient Peru is a matter of record. Writing before 1630, the Spanish historian Father Bernabé Cobo observed that swarms of mice would periodically descend from the sierra to invade the fields. On yet another vessel (fig. 13), on loan to the Art Institute, such a swarm is depicted using the design convention of repetition employed by the Nazca in order to represent species that occur in aggregations. This pictorial formula can be seen on a number of vessels depicting rookeries of sea birds, clusters of crayfish, or herds of guanacos (a wild relative of the domestic llama).

Like serpents and frogs, lizards undoubtedly had associations with the earth or seasonal moisture that they often had in other Indian cultures. On one of the most beautiful vessels in the collection, groups of lizards are shown in diagonal alignments of alternating white and brown (pl. 2). This spiraling pattern of repeated forms covers the surface of the globular jar whose protuberances suggest the swelling of dunes and hillocks of the lizard's desert habitat. The impression of a natural setting is humorously emphasized by a pair of birds painted on the handle, representing the hovering flight of predators above the land. The marvelous geometry of the vessel's shape, rhythmic pattern of the lizards, and warm, burnished orange color of the background make this one of the masterpieces of the Art Institute's Peruvian collection.

Warriors

In addition to the rites and activities associated with cultivation, Nazca art is strongly concerned with the imagery of war. There is little to suggest outside intervention or conquest in these representations; no foreign prisoners appear, nor scenes of homage or tribute-paying rites that might be linked to dynastic conquests beyond the South Coast region. One can suppose then that war for the Nazca people was internal, a result of competition for control over local resources among highly organized communities within the South Coast river valleys—a speculation that must necessarily await archeological proof. One of the finest examples in the Art Institute represents an elegant warrior bearing implements and trophies of his occupation and achievements (pl. 4). The head is exceptionally well modeled, showing considerable detail. Although the face exhibits a certain individuality, it cannot be called a portrait; nowhere in Nazca art is there anything approaching the strong emphasis on portraiture seen in the contemporary Moche ceramic tradition of the North Coast. The torso of the warrior has been abstracted to a cylindrical form conforming to the shape of the

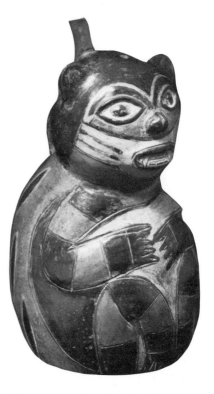

FIGURE 12 Felis colocolo *effigy*, 370/180 B.C. H. 20.96 cm. (1955.1848).

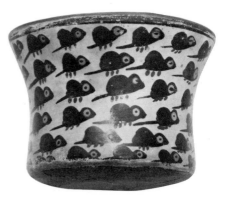

FIGURE 13 *Flared cup or bowl with mice*, c. 55/25 B.C. H. 6.99 cm. On loan to The Art Institute of Chicago from the Hans and Mercedes Gaffron Collection, Chicago.

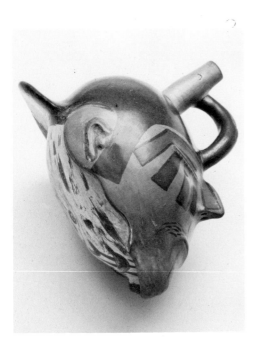

pot, with only slight protrusions to emphasize the shoulders and the position of the legs folded under the body. All items of costume, as well as the arms and hands, are meticulously painted on the pot's curved surface. The warrior holds a dart thrower in his right hand, with its stone counterweight tied at one end, and a chipped stone to support a tilted dart tied at the other.[13]

The Nazca warrior also holds a severed human head in his left hand, and another trophy head is painted upon his back. Among many Indian groups, the collecting of trophy heads was a variant of scalp taking. The practice was observed not only to prove a warrior's personal victory, but also to obtain for himself and his community a magic talisman in which the power of a defeated enemy was thought to reside. A remarkable example of the trophy-head motif is seen in another Art Institute vessel in which all the features are modeled in realistic detail (fig. 14). The lips are sewn together with two spines, the broken vertebra is visible, and the bloodstained neck and severed flaps of skin are rendered with horrifying accuracy.

Representations of violent sacrificial themes have an ancient history in Peru, occurring as early as on the monumental ensemble at Cerro Sechín, dated to about 900 B.C. (see fig. 15). A wall of sculptural reliefs forms the façade of a temple precinct abutting an imposing hill that overlooks the Casma and Moxeke valleys, far to the north of the Nazca drainage.[14] Engraved figures of standing triumphant warriors alternate with grisly rows of trophy heads, spinal columns, and bisected torsos. It is virtually certain that the ensemble records the theme of sacrifice to the sacred mountain and the idea of nourishing the earth with captives taken on the battlefield in a recycling of life forces. In Andean Indian religions today, the ritual sacrifices of llamas as offerings to mountains remain a fundamental practice.[15]

Action on the battlefield itself was commemorated on painted, cylindrical beakers during the late period of Nazca ceramics. One such vessel, finished in the form of a double beaker, is painted with a scene of warriors dressed in short tunics and breechcloths racing across the debris-covered desert (fig. 16). The desert is represented by a dotted mound between each of the running warrior's

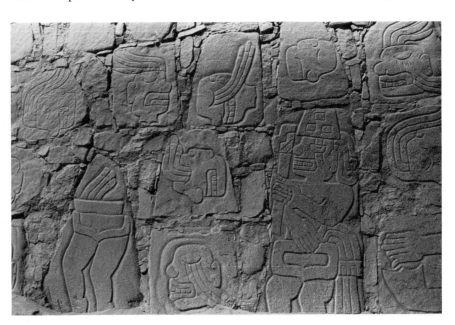

legs, one of the few motifs borrowed by Nazca artists from the ceramic vocabulary of their distant neighbors, the Moche. Above and around the figures, projectiles fly through the air; and garments, darts, and bloodstained cloths are strewn about in violent disarray. Each warrior carries a baton to which feathers appear to be attached. The caricaturelike quality of the drawing and lively sense of motion convey the exertion, danger, and excitement of action on the battlefield.

Pictogram and Costume: The Language of Ritual Attire

The imagery of war found upon Nazca vessels—battlefields, warriors, and barbaric trophies of triumphant raids—stands in contrast to the implements of farmers, the animals, and the bounty of the land that they also display. Yet, the two spheres of action were strangely interwoven, and it was in the art of ritual costume that these links were visibly expressed. In this category of Nazca representation, as well as in that of pictographic figures, the most colorful and imaginative visual statements were created to proclaim the religious bonds of man and land.

The costumed figures in the Nazca ceramic repertory represent ritual performers. They are characteristically depicted wearing whiskered feline masks, complex headdresses, garments, and jewelry of many kinds. Although figures of this type have been referred to in the literature as mythical beings, imaginary beasts, fantastic personages, or demons, there can be no doubt that they represented actual performers—living, moving cult images on religious festival occasions. Elements of the costumes such as wigs, gold mouth masks, diadems, and related objects have actually been recovered (see pl. 6).

Constituting one of the fundamental, widespread categories of Indian religious imagery throughout the Americas, masked figures appear in cultures much older than the Nazca. The sculpture and goldwork of Chavin and the figured textiles of Paracas, for example, show a wealth of costumed forms. A rare cloth now in The Cleveland Museum of Art and believed to have been recovered

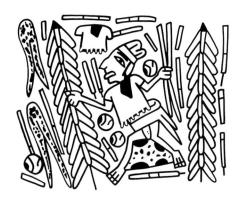

FIGURE 16 *Double cylindrical beakers with warriors*, c. 315/430(?). H. 17.78 cm. (1955.2008).

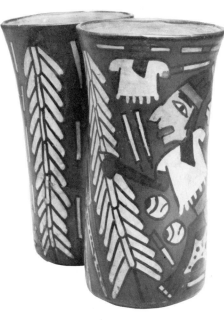

PLATE 6 *Mouth mask with feline motif*, c. 175/25 B.C. Gold; w. 12.7 cm. (1955.2609).

FIGURE 17 *Mantle* (detail), from a burial ground in the vicinity of the Paracas Peninsula, c. 25 B.C./A.D. 65. Cotton cloth, paint; 68.6 × 254.2 cm. The Cleveland Museum of Art, The Norweb Collection (40.530).

from the Paracas Peninsula burial grounds, to the north of the Nazca heartland, depicts a procession of these figures, painted in a relatively naturalistic style (fig. 17). Unlike representations of the gods of Mediterranean antiquity that emphasize the human figure, in the New World the human form as such was usually of secondary interest.[16] Extraordinary attention tended to be paid to the masks, garments, and accessories with which the figures were identified, while comparatively cursory treatment was given to bodies, arms, hands, and legs, except as supports for these emblems and items of apparel. The Nazca were no exception to this general rule. A figure in another fine vessel illustrates this point (pl. 3): the body and legs are reduced to abstract appendages below the enlarged mask and headdress, and the arms and hands are similarly conventionalized, holding a pair of trophy heads and a club or baton. The mask is the dominant motif, with its feline-whisker mouthpiece, multicolored necklace, circular side disks, and forehead diadem. Other masklike forms, probably representing trophy heads, comprise part of the headdress down the performer's back. It was clearly the artist's intention to spell out the meaningful elements of costume, making the figure a veritable alphabet of ritual attire.

There is considerable variety in the bizarre, often fearsome costumes of Nazca cult performers, and they have been grouped in related clusters according to elements of dress. Many items of attire are interchangeable, and charting the different combinations is itself a field of study. What did these extraordinary figures represent? What aspects of the Nazca world were they designed to illustrate? Answers to these questions can be found in decoding the pictographic language of this ritual attire.

A pictogram, unlike the image of a plant, animal, or human being, does not represent a physical entity in nature; rather, it abstracts multiple traits and synthesizes them to focus attention on concepts. It is a figural character or symbol representing an idea or perception and its corresponding word or figure of speech. Throughout history, there has been a great range of pictographic forms, including aspects of the hieroglyphic systems of the ancient Maya and Egyptians, which exist as fully developed writing independent of the figural art they accompanied. In other traditions, such as that of Teotihuacan in Mexico, pictographic elements only begin to emerge from the surrounding matrix of

representational art without attaining the articulation and independence of fully developed hieroglyphic writing. Simultaneously, representational imagery has an abstract character that suggests a pictographic function. In these broad respects, Nazca art has closer affinities with Teotihuacan than with the Egyptian or Maya systems. While we do not know what words were used by the Nazca in connection with their visual images, the general ideas and associations to which they refer are within our grasp.

Two vessels from our collection illustrate well how pictographic images are formed. The first represents a fishlike figure (fig. 18), which is not of any identifiable species but a composite creature with shark and killer-whale (orca) elements: a powerful body, spiky dorsal and ventrical fins, and a large mouth with aggressive, serrated teeth. The creature also has a human arm and hand, which clutches an abbreviated trophy head. This was not simply an imaginary beast, a fairytale monster of the Nazca imagination, for its elements have been brought together because of specific meanings: the shark and orca are both major sea predators; and the trophy head is a sign of the warrior, chief predator (to the Nazca, at least) on land. Thus, this image carried messages about power and hierarchies, the control of territory, and the ability or function of taking life; it may also have conveyed notions of protection or warning to invaders who might trespass on the Nazca domain. It has been speculated that such images may also reflect an ancient South American Indian belief known as the "Master of Fishes,"[17] which maintained that chief predators such as sharks or orcas assume guardianship over other beasts in their watery domains, threatening anyone who dares displease them but offering protection and a rich bounty to those they favor. On the second vessel, the pictogram is more complex (pl. 1). Again, we find a fishlike body, human hand, trophy head, and club or baton. But, instead of open jaws, the face is masklike, with feline whiskers, forehead diadem, and dangling disks. The energetic, curving body; violent signs of war; and fixed, hieratic mask create a forceful, complex pictogram of chief predators in the animal and human kingdoms.

Other vessels show how the imagery of war was linked to agriculture in the Nazca world. In the first example, an extraordinary design, the artist wrapped a ritual figure around the curving surface of a small flared cup (see fig. 19). Here again is the familiar feline mask and all its accouterments, as well as a trophy head and baton held in stylized hands. The torso is indicated by a striped rectangular garment bordered by a fringe, and a breechcloth appears below, from which the lower legs protrude. The mask is provided with a long train, to which three trophy heads are attached, and which ends in a stylized lizard surrounded by seeds and pods. As the actual performer danced in a ceremony, this lizard—an animal associated with the earth—would have appeared to crawl upon the seed-

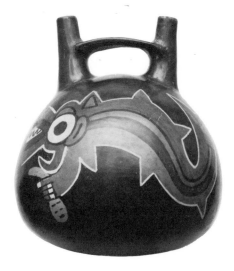

FIGURE 18 *Globular jar with pictogram*, c. 115/55 B.C. H. 17.93 cm. (1955.2097).

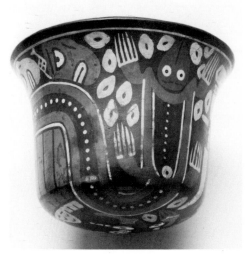

FIGURE 19 *Flared cup with ritual performer*, c. 25 B.C./A.D. 65. H. 8.26 cm. (1955.1928).

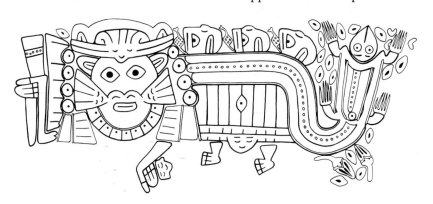

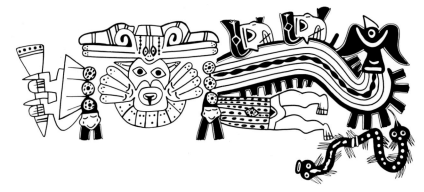

FIGURE 20 *Ritual performer with* vencejo *headdress* (drawing), after a globular jar, c. 25 B.C./A.D. 65. (1955.2041).

strewn ground. The second example is the decoration of a globe-shaped jar (see fig. 20) in which the figure combines feline and warrior attributes, and all the other customary elements of costume including trophy heads. But, in this case, the mask train ends in a *vencejo*. On the bottom of the vessel, in a position corresponding to the earth, the symbol of the swallow's prey is drawn as a double-headed centipede. We may imagine that, as the performer danced, the swinging train with the *vencejo* suggested the swooping flight of the bird across the fields and areas of cultivation. In both of these examples, animals, agriculture, and the rites of war are linked to life and death.

In an especially strong statement of military and agricultural relationships, the design on a deep, flared-edge bowl (fig. 21) depicts paired performers wearing feline masks, below which abstracted bodies and lower limbs appear. The headdresses are unusually complex: a row of cactus fruit is aligned upon the forehead diadem, appearing again on the flowing train of the headdress. Trophy heads are also featured, with pepper plants and cactus fruits protruding from their mouths. A bizarre touch is included below, where a row of mice is suspended from appendages or tabs. Could these be trophy mice, the prey of felines and symbolic counterparts to the heads of human enemies displayed in an agricultural context above? The association is plausible if not certain, for just as a plague of mice is consumed by the guardian feline, so too are enemies destroyed by the Nazca warrior. A final note of savage ceremony is struck by the warrior's outstretched hands: instead of the usual baton and trophy head, they hold the dismembered halves of a human being. The parallel between this figure and the

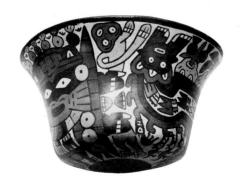

FIGURE 21 *Flared cup or bowl with ritual performers*, c. 25 B.C./A.D. 65. H. 9.23 cm. (1955.1934).

134

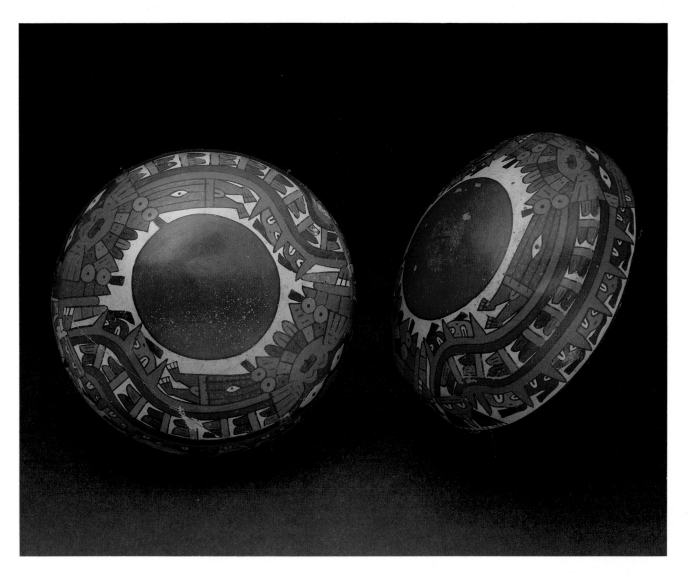

PLATE 7 *Matched bowls with ritual performers,* c. 25 B.C./A.D. 65. H. of each, 8.59 cm. (1955.1937-38).

older imagery of Cerro Sechín is especially striking, underscoring the ancient theme of sacrificial covenants that bound man and land.

The earth-cult theme is the subject of an especially elegant and colorful pair of superbly matched bowls in the Art Institute (pl. 7). It is not often that Nazca vessels have a known archeological site provenance, but on one of the vessels a penciled note made in the original collector's hand indicates that it was recovered from Cahuachi. The bowls are identically designed, with ritual performers symmetrically disposed around the outside rims, while the circular bottoms are colored in disks of deep Indian red. As in other examples we have seen, the costumes include feline masks, batons or clubs, and headdresses set with trophy heads. In this case, the heads alternate with spiky elements that may derive from stylized representations of fins on the shark/orca pictograms. The central strip of the train is further elaborated with aligned symbols of *yuca*. The rhythmic design, unusually rich color scheme, and technical virtuosity of these vessels indicate not only the high aesthetic level of Nazca art, but also a sense of ceremonial discipline and the formations of ritual dance.

The last vessel from the Art Institute collection to be discussed has already been mentioned. It is the lyrical jar (pl. 5) whose shape is related to that of the lizard-landscape vessel (pl. 2). As in that earlier example, the walls of the container form protuberances, conventionally associated with the idea of landscape. The surface is painted as a hilly desert, populated by foxes, cacti, and serpents. Other star-shaped motifs are scattered randomly about, probably in reference to sections of the stem of the hallucinogenic San Pedro cactus, and the shadowy, brown background evokes a mysterious nocturnal mood. These motifs pertain to visible, tangible phenomena, but underlying them is another realm of mythic forces, manifested by the two large, centipedelike creatures that traverse the setting. The meaning of these outsized creatures, who resemble waving trains of ritual masks more than they do desert inhabitants, is presently unknown. Might they be visual puns or metaphors, representing the winding irrigation canals with small ditches branching out into the fields?[18] Or could they refer to the huge animals and lines drawn upon the desert? There is no ready explanation now, but at a fundamental level it is possible to see that the figures on this dreamlike vessel speak of a sacred geography, and once again of metaphors and rites through which the Nazca joined themselves to nature and the landscape in which they lived.

Conclusion

Our first response to Nazca ceramics in an exhibition gallery is to the purely visual, aesthetic appeal of the objects. But a more detailed examination soon leads us to new thoughts and visual experiences, as individual vessels show themselves to be components of a larger figural and pictographic system. We cannot decipher this art in all its original complexity or with the certainty that might have come with the availability of written texts. But, by considering the categories of form in the light of available archeological data, local ecology, and known religious beliefs and practices of Andean peoples in the present and past, it is possible to outline the structure of this system of visual communication. The basic categories of Nazca imagery appear to persist throughout the 600-year tradition, despite changes of specific subjects, shifts of local style, and other regional differences. These larger categories of imagery describe the order of the Nazca world.

As we have seen, each vessel may be understood within a larger context of forms, its meaning deriving from the vision of the universe as it was perceived by the Nazca population. However, learning of this structure does not yet answer all the questions, for we are pulled deeper into still unsolved issues. What were the specific uses of these vessels? Why was there seemingly no concern to represent historical events? Why, in contrast to the North Coast, was there no emphasis on portraiture, architecture, domestic life, or episodic scenes of ritual and myth? What is the relationship between this ceramic art and that of Nazca textiles? Such questions may be answered by current excavations at Cahuachi and related sites and burial grounds, by future investigations, and by reflecting on the contours of a world view that the ceramics portray.

Although the unique forms of Nazca art reflect a world that seems isolated in its own time, it can nevertheless be understood in terms of larger patterns of Andean thought and symbolism. Preeminently chthonic (relating to powers of the earth), rooted in an empirical understanding of mountains and waters, the Nazca symbolic system reveals the ancient and enduring way in which Andean Indians have considered themselves in relation to their land. Just as the precarious life of these austere valleys is periodically reborn with the downward flow of waters from Andean slopes, to eventually wither, perish, and be renewed again, so, too, a social and cultural life took shape that participated in and ensured through ritual covenants this eternal return to the beginnings. While our view of Nazca art is still incomplete, it is possible to see that its complex ritual imagery and sacred geography is not entirely that of a fossilized way of life or of an extinct civilization. It represents instead an early chapter of a widespread and still vital cultural tradition with important messages for us today.

A series of pictures rises in the mind's eye upon regarding these powerful ceramic images. In the luminous expanse of the desert, long lines lead toward ridges and heights on the horizon, or converge on vantage points above the cultivated valleys. Shadows reveal the fissures, ravines, and stony outcrops of barren rock formations. In the distance, beyond these bare bones of the earth, pinnacles of the distant Andes rise in pale blue ranges. It is a country of wide horizons, where one is conscious of the huge spaces of land and sky. There is a sense of brooding, primeval quietness in this solitude, and a feeling of the aloofness of the landscape. Below, over the rim of the arid plateau, a valley shows its green patchwork of fields and gardens, a broad meandering riverbed, and blue-green threads of irrigation ditches. There is protection there, sanctuary from the impersonal, alien surface of the surrounding desert. But, the great lines and drawn effigies have made whole sections of that desert vast ritual arenas. On festival days, long formations of barbaric figures move to the cadence of drums and the eerie sound of pan pipes and high-pitched, wailing flutes. The processions of brilliant costumes glitter with metallic masks; headdresses and waving tails move in rhythmic cadence; and sacrificial instruments and bloodstained trophies are displayed in the dancers' hands. These processions, gestures, and costumes call to the mountains and spirits, to the water that flows underground, and to all the organic forms with which human life is bound. The dancers bring the viewer across the border of profane time, beyond the ordinary boundaries of temporal duration, into a mythical time at once enchanted and frightening—a time recalling not the transitory events of daily life, but an order of things that had been established *in illo tempore*, the time of first creation.

NOTES

Special thanks must go to Joanne Berens for her assistance with this article and for preparing the drawings that appear herein. Thanks also to the students who participated in the undergraduate art seminar given by Northwestern University in the spring of 1984: they completed valuable research in the first stages of this project.

1. The Wassermann-San Blas Collection was formed in Peru in the early decades of this century, and was purchased in the 1950s by Nathan Cummings of Chicago. See especially Walter Lehmann and Dr. Heinrich Ubbelohde-Doering, *Kunstgeschichte des Alten Peru* (Berlin, 1924); J. B. Wassermann-San Blas, *Cerámicas del Antiguo Peru* (Buenos Aires, 1938); H. Ubbelohde-Doering, *Kunst im Reiche der Inca* (Tübingen, 1952); and Alan Sawyer, *Ancient Peruvian Ceramics* (New York, 1966).

2. Sawyer (note 1), pp. 123–33; Donald A. Proulx, *Local Differences and Time Differences in Nasca Pottery* (Berkeley, 1968), pp. 92–100. Two earlier and especially valuable studies are: Alfred L. Kroeber, *Toward a Definition of Nasca Style, University of California Publications in American Archaeology and Ethnology* 43, 4 (Berkeley, 1927), pp. 327–432; and Anna H. Gayton and Alfred L. Kroeber, *The Uhle Pottery Collections from Nazca, University of California Publications in American Archaeology and Ethnology* 24 (1927), pp. 1–46.

3. Four articles by Eugenio Yacovleff are especially important in these identifications: "Las falcónidas en el arte y en las creencias de los antiguos peruanos," *Revista del Museo Nacional* (Lima) 1, 1 (1932), pp. 35–111; "El vencejo (Cypselus) en el arte decorativo de Nasca," *Wira Kocha* 1 (1931), pp. 25–35; "La deidad primitiva de los Nasca," *Revista del Museo Nacional* (Lima) 1, 2 (1932), pp. 103–60; and "La jíquima, ráiz comestible extinguida en el Peru," *Revista del Museo Nacional* (Lima) 2, 1 (1933), pp. 51–66.

See also Luis Valcárcel, "El Gato de Agua, sus Representaciones en Pucará y Nazca," *Revista del Museo Nacional* (Lima) 1 (1932), n. p.; Eduard Seler, "Die buntbemalten Gefässe von Nazca," *Gessamelte Abhandlungen zur amerikanischen Sprach- und Altertumskunde* (Berlin, 1923), vol. 4, pp. 160–438; and A. Sawyer, "Paracas and Nazca Iconography," *Essays in Pre-Columbian Art and Archaeology* (Cambridge, Mass., 1961), pp. 269–98.

Much of this information has been effectively summarized in a recent catalogue of Nazca ceramics in the Museo de Américas, Madrid. This useful publication presents the pottery in chronological order, with commentary on stylistic development and the identification of iconographic motifs and themes. See also Concepción Bosqued Blasco and Luis Javier Ramos Gomez, *Cerámica Nazca* (Valladolid, 1980).

4. This program is being conducted by Helaine Silverman of the University of Texas, Austin, and Miguel Pazos and Enrique Bragayrac of the Museo Nacional de Arqueología y Antropología, Lima. A sketch plan of Cahuachi was published by William D. Strong in "Paracas, Nazca, and Tiahuanacoid Cultural Relationships in South Coastal Peru," *Memoirs of the Society for American Archaeology* 13 (1957), pl. 4.

5. A summary review of the literature on this subject will be included in Johan Reinhardt, "The Nazca Lines, Mountain Worship, and Economic Production," *Boletín de Lima* (forthcoming).

6. George Kubler, *The Art and Architecture of Ancient America* (Baltimore, 1962), p. 286.

7. See Gary Urton, "Astronomy and Calendrics on the South Coast of Peru," *Ethnoastronomy and Archaeoastronomy in the American Tropics* 385 (1982), pp. 231–47; Phyllis Pitluga, "The Ancient Nazca Markings," lecture presented to the Chicago Archeological Society, February 24, 1985.

8. Reinhardt (note 5). See also idem, "Las Montañas Sagradas: Un Estudio Etnoarqueológico de Ruinas en las Altas Cumbres Andinas," *Cuadernos de Historia* 3 (July 1983), pp. 27–61. For an especially valuable explanation of mountain worship in a modern

Aymará community, see Joseph W. Bastien, *Mountain of the Condor: Metaphor and Ritual in an Andean Ayllu* (St. Paul, Minn., 1978).

9. Richard F. Townsend, "Pyramid and Sacred Mountain," *Ethnoastronomy and Archaeoastronomy in the American Tropics* 385 (1982), pp. 37–62.

10. See Yacovleff citations (note 3).

11. Blasco and Gomez (note 3), pp. 96–97.

12. See C.A.W. Guggisberg, *Wild Cats of the World* (New York, 1975), pp. 101–02. Special thanks for assisting in this identification go to Dr. Bruce Patterson and Dr. Philip Herskovits, Department of Mammals, Field Museum of Natural History, Chicago. Several specimens of *Felis colocolo* in that museum's collection display the distinctive banded legs and spotted backs seen on the Art Institute vessel and on other felines in Nazca ceramic imagery.

13. When the projectile is fitted into position and the thrower held as an extension to the arm, considerable velocity and distance are added to the throw. Such implements have a long history, greatly antedating bows and arrows in the Americas. Dart throwers are still found in use among such peoples as the Australian Aborigines, whose basic technology has been handed down since Paleolithic times.

14. Kubler (note 6), pp. 238–39.

15. In the high mountains of Peru and Bolivia, the slopes and fields of many communities are dotted with *apachetas*, small stone or earthen shrines where such offerings are regularly made. See Bastien (note 8), pp. 51–83.

16. For a discussion of ritual costume imagery in Aztec art, see R. F. Townsend, *State and Cosmos in the Art of Tenochtitlan* (Washington, D.C., 1979), pp. 23–36.

17. An excellent discussion of the "Master of Fishes" theme appears in Patricia J. Lyon, "Female Supernaturals in Ancient Peru," *Ñawpa Pacha* 16 (1978), p. 126.

18. Personal communication with Dr. Alan Kolata, Department of Anthropology, University of Illinois, Chicago. Dr. Kolata has conducted excavations at Chan Chan on the North Coast of Peru, and in the vicinity of Tiahuanaco, Bolivia. The pattern of ancient irrigated fields in relation to main water channels is similar to that of the feet and body of our painted Nazca creature.

Up and Down, In and Out, Step by Step, A Sculpture, a work by Daniel Buren

ANNE RORIMER,
Chicago

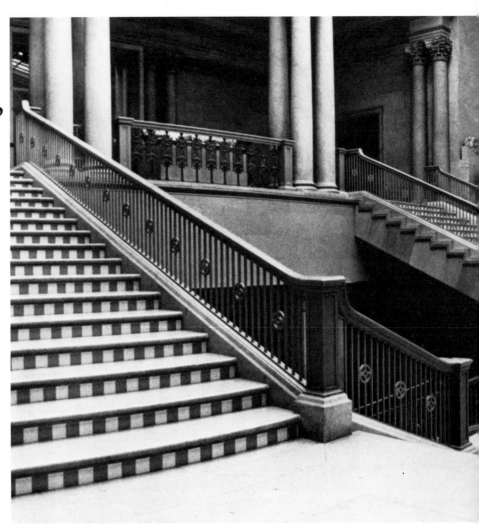

*T*HE NUMEROUS WORKS of art that Daniel Buren has executed here and abroad over the last two decades bear witness to an impressive oeuvre. Born in France in 1938 and recognized internationally for nearly 20 years, Buren has contributed to the radical redefinition of contemporary art. The Art Institute of Chicago, continuing its commitment to the art of the present, acquired Buren's 1977 *Up and Down, In and Out, Step by Step, A Sculpture* (figs. 1–3) for its permanent collection in 1982. Consideration of this major example of recent art in relation to other works by this artist not only leads to an understanding of Buren's approach in general but also serves to elucidate the artistic goals of the 1970s as these have evolved from and revised those of the 1950s and 1960s.

Throughout his career, Buren has sought to reevaluate prior ideas about art in order to discover alternative avenues for visual experience. Works by Buren are generally executed outside of the traditionally defined exhibition space. Always done "in situ,"[1] they are allied with a specific site and exist physically only during the period of their exhibition. For every work, the artist uses fabric or other material that has been printed with alternating white and single-colored vertical bands measuring 8.7 centimeters (about 3½ inches) in width. The artist's decision concerning where to adhere or hang the striped material governs the physical form and meaning of each new work.

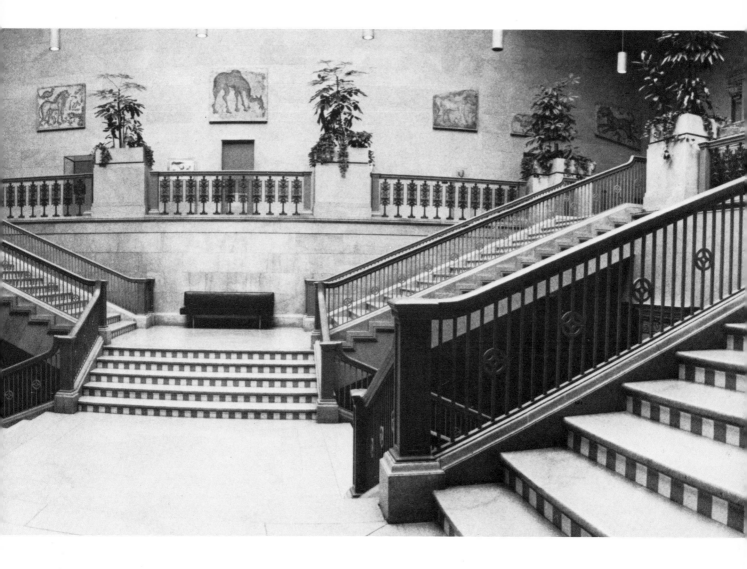

Buren arrived at the decision to limit the format of his work to printed vertical stripes in 1965. After several years of experimentation in search of the means to create "a work of which nothing can be said except that it is,"[2] he concluded that the adoption of prefabricated material (visually not unlike the kind used for awnings, canvas furniture, etc.) would eliminate the mechanical necessity of painting the stripes himself. The repetitious vertical bands meet Buren's requirement for painting that is "simply to exist before the eye of the viewer,"[3] as they themselves offer no message or painterly materiality. With the interpretive, personal touch of the artist removed, the stripes function purely as visual fact.

Although the consistently repeated vertical format that provides the "internal structure" of each work, according to the artist, "remains immutable,"[4] varying only with respect to color, each piece is unique. In 1968, Buren began to extend his concerns beyond the traditional confines of the studio. Since then, every work has been directly related to and affected by the conditions of its placement. A brief analysis of several of Buren's important pieces points to their extraordinary visual variety and lends insight into the nature of his intent.

Two works of 1968, among the earliest implemented outside the studio, are seminal to Buren's later development. For the first of these, done in Paris that year, Buren pasted some 200 rectangular sheets of green-and-white-striped paper to many of the billboards found throughout the city and its suburbs. He placed

FIGURE 1 Daniel Buren (French, born 1938). *Up and Down, In and Out, Step by Step, A Sculpture*, 1977, photo/souvenir: a work in situ. The Art Institute of Chicago, Twentieth Century Discretionary Fund (1982.44). Installation view (detail), 1977, looking north. Photo: Rusty Culp. In this and all other works by Buren illustrated here, the material used, unless specified otherwise, is white and colored striped paper in vertical bands 8.7 cm wide adhered to the surface by glue.

141

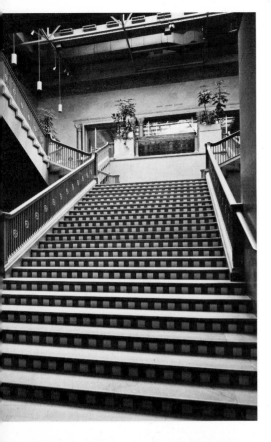

the striped rectangles randomly over or beside advertisements of every kind, juxtaposing them with the commercial statements and images already there (see fig. 4). In speaking of this work, Buren emphasized that he accomplished it anonymously and without permission, that is "without invitation, and without commercial support and without a gallery."[5] The work materialized quite literally "without," and thus "outside of," the usual framework of artistic activity. Neither contained like a painting on canvas within the edges of a frame, nor shown as part of the conventional exhibition system, it was inserted instead into the context of everyday, outdoor advertising display. Buren thus ingeniously succeeded in producing a work that had no designated author and communicated no inherent message. Moreover, glued beside and over all manner of advertisements, the striped rectangles, viewed as works of art, ironically did not possess any institutional or economic "backing" of their own. Through his deliberate negation of museum or gallery auspices, Buren opened to question the accepted methods of both making and exhibiting art in order to reevaluate the interrelated roles of authorship, content, and presentation in the creation of aesthetic meaning.[6]

The second work of this early period of Buren's career similarly took issue with—in order to analyze—preconceived assumptions about the institution *of* art and the institutions *for* it. As his contribution to the invitational "Salon de Mai" exhibition of 1968 at the Musée d'Art Moderne de la Ville de Paris, he adhered a large piece of green-and-white-striped paper, 15 feet high and 54 feet long, to one of the museum's interior walls. At the time this exhibition was in progress, he hired two "sandwich men," frequently seen in Paris in those years, to walk around the neighborhood of the museum wearing their customary placards. In place of the publicity advertisements for shops, announcement of films, etc., which they normally carried, Buren's sandwich men bore signboards covered with the same green-and-white-striped paper used on the wall in the exhibition. Circulating anonymously through the streets, the striped signboards contrasted significantly with the officially presented work of art in the museum (see fig. 5). They pointed to the fact that different assumptions pertain to the perception of a work that is viewed on the premises of an art institution than to one that utilizes commercial display systems of street advertising. Whereas the work pasted on billboards completely circumvented traditional methods of exhibiting art, it functioned outside the museum yet had specific reference to it.

Like these two Paris pieces, all of Buren's succeeding works are derived from and inserted into existing reality—a non-art context. Explaining, for example, the way in which he arrived at a work of 1969 for the Wide White Space Gallery in Antwerp, Buren described how he applied striped paper, the same as he used for the invitational poster for the exhibition, to the flat plinth that ran along the outside of the gallery's building. The striped material followed the contours of the plinth from a hydrant beside the building to the doorway, and from the doorway into the gallery itself (see fig. 6a–b). Instead of hanging traditional

Top
FIGURE 2 Buren. Installation view of figure 1 (detail), looking east. Photo: Rusty Culp.

Bottom
FIGURE 3 Buren. Exterior portion of figure 1, Michigan Avenue entrance. Photo: Rusty Culp.

paintings on the gallery walls, Buren gave shape to this work by way of the external architectural detailing, extending the colorful series of stripes on line with the chosen plinth from the outside of the building to the space within. As Buren concluded, "the piece inside the gallery, thus dictated by the situation outside, uses only the space available as a result of the given architecture."[7]

Sail/Canvas, Canvas/Sail (1975–76), a work in two phases, once more illustrates how the given reality can determine the resulting work. For the first phase of this piece, Buren organized a sailboat race on the Wannsee, Berlin's large lake. Nine boats were rigged with sails made with his characteristic striped material, each of a different color—white with yellow, blue, red, green, or orange, etc. Steered by children, they could be seen from the shore as the wind propelled them through the water at various speeds (see fig. 7a). Some months later, for the second part of the work, he hung the sails on one of the long walls of the Berlin Akademie der Künste as if they were paintings (fig. 7b). Spacing them evenly, he arranged them in the sequence of their boats' arrival at the finish line of the race.

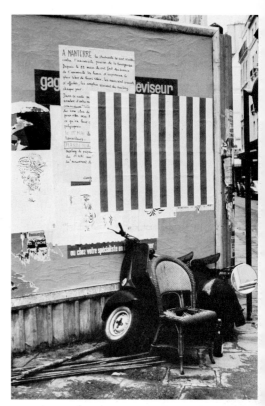

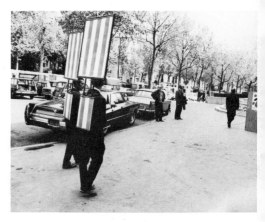

FIGURE 6a-b Buren. Untitled, 1969, photo/souvenir: a work in situ. Installation at the Wide White Space Gallery, Antwerp, showing exterior and interior views. Photos: the artist.

Top
FIGURE 4 Buren. Untitled, 1968, photo/souvenir: a work in situ. Installation view of green and white papers pasted on 200 billboards in Paris and its suburbs (detail). Photo: the artist.

Bottom
FIGURE 5 Buren. Untitled, 1968, photo/souvenir: a work in situ. View of green and white paper on signboards carried by "sandwich men," Paris (detail), during exhibition of piece by Buren in the Musée d'Art Moderne de la Ville de Paris. Photo: Bernard Boyer.

FIGURE 7a-b Buren. *Sail/Canvas, Canvas/Sail*, 1975-76. Photo/souvenir: a work in situ, using printed sailcloth, showing exterior and interior phases of an exhibition organized by the Berliner Künstlerprogramm (DAAD) and the Folker Skulima Gallery, Berlin. Geneva, Selman Selvi Collection. Photos: the artist.

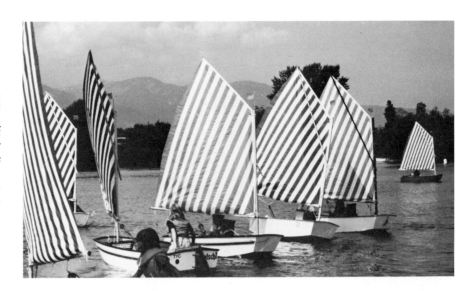

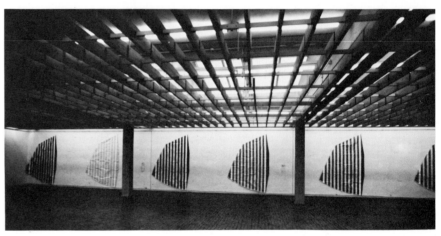

In this instance, as the double-entendre of the work's French title (*Voile/Toile, Toile/Voile*) suggests, canvas sails and sails as paintings are one and the same. Buren himself has written, "the form [of this work] is defined solely by the function of the canvas [*toile*] in its capacity as sail [*voile*]." [8] Furthermore, once on exhibit in the museum, where art is supposed to be housed, the sails unquestionably could be viewed as art objects. Having first staged this work in a non-art situation and afterward having subjected it to the traditional methods of fine-art display, Buren exposed—while he also bridged—the gap between the interior and the exterior of the traditional exhibition area and between generally accepted art and non-art contexts.

Every work by Buren both acts upon and is activated by its context. His examination of the significant role of all aspects of the museum or gallery context in the interpretation of art is central to his approach. A work may be physically placed in a public, non-art situation like the Paris billboards or, like the Berlin sailboats, it may dialectically connect an art and non-art environment. In the case of a one-person exhibition in 1975 at the Städtisches Museum Mönchengladbach, Buren chose to work totally within the traditional exhibition space itself.

In preparation for his Mönchengladbach work, entitled *Starting from (A Partir de là)*, Buren studied nearly ten years of successive exhibitions held at the Städtisches Museum, which had been founded on the premises of a large private house. By means of documentary installation photographs and with the help of

the museum's director, he was able to distinguish an essentially unvarying approach to the placement of art works that the institution had followed for nearly a decade. From his summary of these installations, Buren derived a composite pattern of rectangular voids. For the resulting work, he covered the walls of all rooms on both floors of the museum with striped fabric, choosing blue and white material for the ground level, brown and white for the stairway walls, and red and white for the upper level. Wherever a painting—selected from a cross-section of the museum's numerous shows—had once hung on the wall in a particular spot, he cut a rectangular section to size out of the striped material so that the bare wall behind showed through (see fig. 8).[9]

The conspicuous absence of actual paintings gave striking visual presence to the wall, the support that normally is unseen. As a result, the background wall came to be read as foreground. As Buren has asked, "Is the wall a background for the picture or is the picture a decoration for the wall? In any case, the one does not exist without the other."[10] Since the museum's installations over almost a decade proved to be nearly identical in terms of the placement of objects, Buren was able to exhibit the customary nature of presenting art. He revealed the ingrained assumptions of our culture concerning the display of paintings, since they tend to be hung on walls at eye level, according to size, and at specified distances apart.

As Buren has noted, his one-person exhibition at Mönchengladbach functioned as a retrospective of the museum's own exhibition history.[11] The nature of accepted modes of museum presentation was the subject of a work in which content and context merged. *Starting from*, with its emphatically striped walls pierced by the shapes of paintings once present, existed within the supporting framework of the museum, from which it could not be detached, since the work was inseparable from its container.[12]

In each new set of circumstances, Buren discovers aspects of the site or situation that he turns to the purposes of his art. A work exhibited from October 1980 through May 1982 at The Art Institute of Chicago took advantage of the fact that the museum extends over an active railroad line, probably a unique phenomenon for any major museum anywhere. One large window of the museum in the Morton Wing stairhall exhibition area overlooks the tracks, which run beside and under the building. With the cooperation of the city of Chicago's transporta-

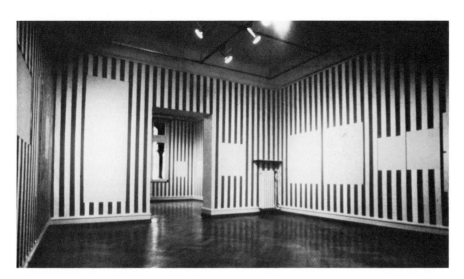

FIGURE 8 Buren. *Starting from (A Partir de là)*, 1975. Photo/souvenir: a work in situ using printed fabric adhered to the surface with glue (detail). Städtisches Museum Mönchengladbach, West Germany. Photo: the artist.

tion system, Buren enlisted the commuter trains that regularly pass the museum to realize his piece, titled *Watch the Doors Please*. He adhered a weatherproof vinyl material printed with stripes—white with red, blue, yellow, purple, or green—to the central double doors of the entire fleet of train cars servicing the south side of Chicago and its suburbs. A label with the train schedule at the museum window informed museum visitors when they might catch a glimpse of a two- or four-car train with colorful, rectangular doors whose color sequence depended on how the cars were linked together randomly at the yards each day.[13]

Watch the Doors Please dramatically reversed the traditional art-viewing process. It was not affixed to a wall or confined to a specific gallery. Subject to the conditions of real time and place, it came instead *to* the viewer, who had to wait for the work as he or she would for a train. The expansive glass window of the Morton Wing—whose mullions resemble gigantic, over-lifesize stretcher bars—functioned as if it were a huge transparent canvas and provided a ready-made frame through which to see the work (see fig. 9). The striped, rectangular doors passing at various intervals in front of the window's frame were not an illusionistically depicted image, but a colorful actuality. Replacing both picture frame and canvas, the window in radical fashion brought about the total fusion of observed reality and art.

The commuter trains literally served as the vehicle for a work of art that conjoined this renowned art museum to the commercial, quotidian world surrounding it. The striped doors, being rectangular, suggested moving paintings and ironically alluded to the tradition of painting on canvas they had left behind. They could be seen not only from within the museum but also from station platforms or bridges; from a distance, they appeared as transitory flecks of color, highlighting the Chicago skyline or animating the suburban homes and shrubbery they passed intermittently. Without attempting to impose the assumptions of an art context upon a non-art context, *Watch the Doors Please* traveled back and forth between and united otherwise separate worlds. In themselves, the stripes could be read purely as decorative elements. Commuters unaware of the work even interpreted them as a new safety feature of the transit system.[14] Framed by the window of a prestigious art institution, however, the striped doors had to be dealt with as part of the discourse of art. The work as a totality, therefore, engendered multiple points of view and opened the door for dialogue on a number of levels. Just as the conductor admonishes passengers to pay attention upon entering the train by announcing "watch the doors, please," Buren's work in parallel manner urged museum viewers at the window to be aware of, and look beyond, the prescribed boundaries of art.

Watch the Doors Please, therefore, fulfilled Buren's aspiration for an art that dispenses with the traditional canvas, which, for him, is a mask that, under the guise of self-sufficiency, conceals by ignoring the realities of its given context.[15] "Right from the start," Buren has affirmed, "I have always tried to show . . . that indeed a thing never exists in itself. . . ."[16] Dispensing with the canvas as his arena of activity, Buren investigates beyond its borders in order to visually involve the work's total frame of reference. "Where the empty canvas was once both the authority and the obstacle as a medium for experiment, today the authority of the institution is the only medium available for the artist," according to the artist.[17]

Fulfilling museums' institutional requirements for acquiring and housing objects for their permanent collections, Buren's *Up and Down, In and Out, Step by Step, A Sculpture* (see figs. 1–3) exemplifies the way in which he has succeeded in establishing an entirely new relationship between the work of art and its surroundings. *Step by Step . . .* was originally created for "Europe in the Seven-

ties: Aspects of Recent Art," an exhibition featuring the work of 23 artists that was held on The Art Institute of Chicago's second-floor, East Wing galleries during the fall of 1977.[18] For this work, Buren cut green-and-white-striped paper to size and glued it to all of the risers of the museum's Grand Staircase, which led up to the rest of the exhibition galleries (fig. 1). He also put the striped material on the lower level staircase risers (fig. 2) and—on line with the main interior stairs—continued the work outdoors on the steps of the Michigan Avenue entrance (fig. 3), as the accompanying label and diagram specifically indicated. When the work was purchased later for the museum's permanent collection, the artist stated that the choice of color for the printed stripe should be made by the curatorial staff and further suggested that this color might change with each reinstallation of the work. The continuation of the stripes on the stairs that lead to the lower level and on those outdoors remains an optional extension of the piece, but the striping of the risers of the entire Grand Staircase is necessary for the work's completion. As with any item in a collection, this work may be installed for any period of time and removed at any point, but, unlike a traditional painting or sculpture, it exists *only* when on view. Like all works by Buren, *Step by Step* . . . temporally and spatially embodies what is present.

FIGURE 9 Buren. *Watch the Doors Please*, 1980-82, photo/souvenir: a work in situ and motion, using printed adhesive vinyl, sponsored by The Art Institute of Chicago with the permission of the Regional Transportation Authority, the Illinois Central Gulf Railroad, and the South Suburban Mass Transit District. View from the interior of the Art Institute's Morton Wing stairhall. Photo: Luis Medina.

147

Although materially and visually concrete, it cannot be severed from its supporting framework to receive life as an object isolated from its appointed context.

Step by Step . . . testifies to the radical developments in art that revolutionized aesthetic practice simultaneously here and abroad in the years following 1968. Precedents for these developments are to be found in the work of a slightly older generation of artists who, generally speaking, have been identified with either the Pop or Minimal art movements. In the early and mid-1960s, these artists challenged and revised previous notions about painting and sculpture and laid the groundwork for succeeding artistic innovation. *Step by Step . . .* takes its historical place in the Art Institute's collection of contemporary art in relation to, but in distinction from, its paintings by Frank Stella or Roy Lichtenstein on the one hand, and its sculptures by Donald Judd, Carl Andre, or Sol LeWitt on the other.

When Buren decided in 1965 to use material printed with vertical bands, he carried even further the significant conclusions reached at the beginning of the decade in this country by artists such as Stella and Lichtenstein. Although visually disparate from one another, the paintings of these two artists share certain ideas and, in turn, parallel Buren's own rationale. In response to the precepts of Abstract Expressionist painting that dominated the decade of the 1950s, Stella by abstract means and Lichtenstein through the use of pre-existing imagery applied new criteria to painting. Stella's *De La Nada Vida a La Nada Muerte* and Lichtenstein's *Brushstroke with Spatter* illustrate the converging attitudes of these otherwise diverse artists.

De La Nada Vida a La Nada Muerte (fig. 10) presents a series of evenly spaced, horizontal lines that change their course at several intervals as they stretch across a 23½-foot expanse. Although the eye instinctively may read the painting from left to right, there is no narrative of any kind, nor any thematic or compositional beginning or end. The painting instead gives the impression of having been cut out of an endlessly repeated pattern of parallel linear elements that regularly veer upward and then resume their horizontal direction. Rather than being contained within a given rectangular format, these horizontal lines serve to define the raised plateaus and notched valley of their outer rim, lending the painting its aspect of being an independent object. In the interest of directness, Stella in this period curtailed any visual incident that would accrue as the result of imagery or compositional arrangement. The work must be viewed as a continuous entity that does not offer the option of isolating one particular section from another.

Conveying frozen energy and movement, *De La Nada Vida a La Nada Muerte* resists interpretation beyond its essential visual impact, a quality reinforced by its metallic paint surface. Referring to this type of surface, Stella recalled that "it had a quality of repelling the eye in the sense that you couldn't penetrate it very well. It was a kind of surface that wouldn't give in and would have less soft, landscape-like or naturalistic spaces in it."[19] The industrial nature of the work's painted surface enhances its impersonal qualities and its implied removal from the hand of the artist. Expressive or compositional considerations exterior to the direct experience of the work itself, therefore, may not easily enter its domain. As Stella has often been quoted as saying, "My painting is based on the fact that only what can be seen *is* there,"[20] meaning that his work does not refer to another or higher order.

Roy Lichtenstein, known at first for his comic-book imagery and more recently for paintings that refer to works by other artists, has also questioned the tenets of Abstract Expressionism, with its emphasis on painterly expression and content. Along with Stella, he has striven to establish the painted surface as an

148

FIGURE 10 Frank Stella (American, born 1936). *De La Nada Vida a La Nada Muerte*, 1965. Metallic powder in polymer emulsion on canvas; 205.7 × 744.2 cm. The Art Institute of Chicago, Ada S. Garrett Prize Fund (1966.335).

independent reality, claiming that his painting "doesn't look like a painting *of* something; it looks like the thing itself."[21] Endeavoring "to hide the record of his hand"[22] so as to endow the painted surface with the appearance of autonomy, Lichtenstein has eliminated direct reference to his own painterly manipulations. He has avoided giving evidence of his personal intervention in order, paradoxically, to lend the painting its sense of directness. His *Brushstroke with Spatter* (fig. 11) parodies the expressionistic use of brushwork characteristic of painting in the 1950s. By depicting the exuberant brushstroke as if it were a representation of a magnified detail from a photographic reproduction, the artist has subjected it to objective scrutiny and has negated it as a descriptive or charged pictorial tool. The depicted image of brushwork and accompanying drips receive a life of their own while being given equal representational status with the surrounding field of painted, photographic dots. The painting thereby signifies the fact that, whatever its subject matter or representational means might be, it is a flat plane and, as such, a reality unto itself.

In the late 1950s and early 1960s, the question of how to make painting a self-referential reality presented itself as a central issue. Through their respective techniques of distancing, artists like Stella and Lichtenstein deliberately suppressed inherent reminders of personal invention and expression that can be evoked by compositional arrangement or brushwork. In the mid-1960s, Buren pushed these attitudes even further. The commercial prefabrication of striped material forces what is on the canvas surface and its actual fabric to merge and allows the artist to dispense with personal, artistic fabrication. Emptying the canvas of compositional, figurative, or landscape elements, Buren uses vertical stripes to deny all expressive reference.

If, during the early part of the 1960s, certain artists turned their attention to demonstrating the primacy of the painted canvas surface *per se*, others investigated the essential nature of three-dimensional form in order to stress the material actuality and presence of sculpture for its own sake. The work of artists like Carl Andre, Donald Judd, and Sol LeWitt (see figs. 12–14) eschews all modes of compositional configuration and personal expression so that any interference with the immediate perception of the work as an essential, material whole is abolished. With their desire to move "away from illusionism, allusion and metaphor,"[23] in the words of their contemporary Robert Morris, they sought to eradicate all traces of figuration.

Buren's reduction of his format to mechanically reproduced, repeated vertical bands bears comparison with this unprecedented approach to sculpture on the part of major artists such as Andre, Judd, and LeWitt. His utilization of commercially printed stripes, moreover, is similar to these sculptors' adoption of industrially available, non-art materials instead of stone, clay, or bronze. Just as the printed fabric of Buren's work negates the intervention of the artist's hand, so

does Andre's use of individual metallic units, Judd's use of plexiglass and stainless steel, and LeWitt's use of baked enamel preclude the handling of material through carving or modeling. Works by these three artists in the Art Institute's collection typify their highly individual, yet analogous, attitudes toward sculpture and mark their innovative rift with the past.

The sculpture of Andre is made up of separate, uniform elements which the artist stacks together or aligns side by side in order to form a single whole. Since 1965, when he decided that sculpture "should be as level as water," Andre has conceived works which, as he puts it, "cut into" space from their position on the ground.[24] *Steel-Aluminum Plain* (fig. 12), a flat, checkerboard square made of steel and aluminum, is composed of single, unjoined squares of identical size. Andre emphasizes the fact that the elements of his sculpture belong to industrial society. Standard and pre-fabricated, "the materials [he uses] have been processed by manufacture."[25] As a method, his repetition of uniform, industrial elements shares an affinity with Buren's repetition of similarly sized, printed stripes.

Although his visual concerns ultimately differ from those of Andre, Judd also depends on industrially available materials for the realization of works that simultaneously contain and are contained by space. In the case of the Art Institute's piece, *Untitled* (fig. 13), the interior and exterior of the object are allotted visual equivalency. Rectangular sheets of deep yellow plexiglass, bolted to the top and around two sides, contribute a glossy, reflective, and translucent surface to a work whose hollow aluminum interior core commands equal visual weight with its exterior. No one part of the work takes precedence over another, while viewpoints are multiple. A slick, shiny, industrial-appearing object that is not handmade, it possesses an air of independent self-containment. Perceived as a single totality, *Untitled* avoids a balanced compositional arrangement of subor-

FIGURE 13 Donald Judd (American, born 1928). *Untitled*, 1968. Stainless steel with plexiglass; 91.4 × 213.4 × 121.9 cm. The Art Institute of Chicago, gift of the Society for Contemporary Art (1969.243).

FIGURE 14 Sol LeWitt (American, born 1928). *Nine Part Modular Cube*, 1977, baked enamel on aluminum; 219.7 × 219.7 × 219.7 cm. The Art Institute of Chicago, Ada Turnbull Hertle Fund (1978.1022). Photo: Rusty Culp.

dinate parts and thereby resists figurative interpretation. In this way, Judd's work relates to the non-hierarchical pattern of stripes employed by Buren.

Speaking of his pieces of 1965, LeWitt pointed out, "Using lacquer, much work was done to make the surface look hard and industrial."[26] At this time, he evolved his "modular structures," wall reliefs or free-standing objects that yield numerous variations on the square and cube. LeWitt's *Nine Part Modular Cube* (fig. 14) is also visually grasped as one entity. It invites an infinite number of angles for viewing; no area of the sculpture dominates over another, nor can any one of its parts be segregated. Presented as a three-dimensional grid, sculpture by LeWitt apportions the space in which it is placed while equally partaking of it. His decision to apply a consistent—although originally arbitrary—ratio of 8.5:1 (representing the material and the spaces in between) to all of his three-dimensional pieces has led to infinite visual possibilities, as have Buren's identically proportioned stripes.

The free-standing sculpture of these three artists, who seek to avoid capricious forms of invention, interacts with the given spatial reality; thus, the placement of

FIGURE 15 Dan Flavin (American, born 1933). *Monument for V. Tatlin, No. 8*, 1964. Cool white fluorescent light; h. 243.8 cm. The Art Institute of Chicago, gift of the Society for Contemporary Art (1978.154).

FIGURE 16 LeWitt. *All Combinations of Arcs from Corners and Sides, Straight Lines, Not Straight Lines, and Broken Lines*, 1973. Installation, white chalk on blue wall (one room) at the Museum of Contemporary Art, Chicago, in 1978.

the work is significant to its visual comprehension. As Andre once claimed, "A place is an area within an environment which has been altered in such a way as to make the general environment more conspicuous."[27] Although their works function as self-sufficient objects, they refer, without deferring to, the surroundings on which they strikingly make their mark. By the mid-1960s, the interchange with the given reality set up in works such as these established a precedent for works, which, in the late 1960s, would directly interconnect with the allotted exhibition space.

Of this generation of artists, Dan Flavin most directly affords in his work a prelude to that of Buren. Early in the 1960s, when Flavin decided to substitute standard fluorescent light fixtures for canvas and paint, he created an unprecedented body of works, such as the Art Institute's *Monument for V. Tatlin, No. 8* (fig. 15), whose substance—light—is their content. During the second half of the decade, Flavin abandoned the traditional, delimited placement of a work on one area of the wall. In coordination with the physical structure of a particular room or rooms, arrangements of pink, blue, green, and/or gold electric lights serve to activate the entire exhibition site. These installations depend on and relate to their architectural settings. Because of the integration of material and background support, they foster an absorbing interplay between white or colored light and space.

Flavin's expansion of the work of art into the surrounding exhibition space opened the entire exhibition area to consideration and use. By 1968, certain artists came to the conclusion that a work need not be separate from the supporting wall. At the end of that year, LeWitt at the Paula Cooper Gallery in New York and the late German artist Blinky Palermo, at the Heiner-Friedrich Gallery in Munich—unbeknownst to each other—decided to produce works directly on the surface of the exhibition wall itself.

The integration of work and architectural setting has been accomplished by different means and to different ends by LeWitt and Palermo. For LeWitt, "the wall is understood as an absolute space, like the page of a book."[28] With the intent of integrating his work with its environment, LeWitt came to the idea in 1969 of "treating the whole room as a complete entity—as one idea."[29] Since then, he has realized numerous wall drawings in exhibition spaces throughout the world. For each work, he adapts a pre-determined system of lines to the chosen space so that "no matter how many times the work is done it is always different. . . ."[30] For example, in a work such as *All Combinations of Arcs from Corners and Sides, Straight Lines, Not Straight Lines, and Broken Lines* (fig. 16),

FIGURE 17 Blinky Palermo (German, 1943-1977). *Treppenhaus*, 1970. Silk-screen print in edition of 200; 60 × 100 cm. Munich, Heiner Friedrich Gallery. This work is based on an installation by the artist in the exhibition "Wandzeichnung Treppenhaus," in Düsseldorf, Konrad Fischer Gallery, in 1970.

the superimposed configuration of linear elements interlocks with their enclosed spatial support so that the work of art and its place of display are brought together as a unified whole. No longer merely supplying a neutral backdrop for a painting or drawing, the wall for LeWitt becomes an integral part of the total work.

Like LeWitt, Palermo, in wall drawings that no longer exist, dispensed with the intermediary canvas surface in order to ally the work with the walls of the room. Rather than adapting a system of lines to the given environment, he correlated the found shapes of architectural elements with the space itself.[31] For an exhibition at the Konrad Fischer Gallery, Düsseldorf, for example, Palermo painted the projection of an ordinary and actual staircase profile (see fig. 17) onto one of the gallery's walls in a suitably proportioned, relatively narrow section of its space, which somewhat suggested a corridor.

Aspects of the wall drawings of these two artists correspond to the radical ideas of Buren. Whereas the work of LeWitt involves the fusion of predetermined linear elements with the existing architectural space, the work of Palermo fuses background support with forms obtained from an architectural reality. Both artists similarly established an interdependent relationship between the exhibition space and the exhibited work of art so that the walls and "image" mesh. Denying the conventional canvas support, LeWitt and Palermo, in similar fashion to Buren, confronted the reality of the exhibition environment and "drew" the context and content of their work together. In addition, Palermo, like Buren, allowed the forms of architectural reality—such as an actual staircase—to prescribe how the resulting work "takes shape." The stairway profile afforded Palermo an undulating form that was extracted from material reality rather than invented. It thus dictated the formal outline of Palermo's wall drawing in the same way that the Art Institute's Grand Staircase determined the sculptural form of *Step by Step.* . . .

The Art Institute's work represents Buren's significant break with artistic practice of the past. Whereas LeWitt and Palermo have defined the context of their work solely in terms of the literal walls of the allotted physical space, Buren has extended the definition of context to include the historical, political, social, and economic systems of support that surround exhibited works of art. Explaining that, "by architecture," he means "the inevitable background, support and frame of any work," Buren has further maintained that, "when we say architecture, we include the social, political and economic context."[32]

Step by Step . . . demonstrates the way in which Buren integrates the work of art with its context, the one reciprocally informing the other. In a text outlining his principles, Buren insisted: "It is not a question of ornamenting (disfiguring or embellishing) the place (the architecture) in which the work is installed, but of indicating as precisely as possible the way the work belongs in the place and *vice versa*, as soon as the latter is shown." He added that, in short, "the object

presented and its place of display must dialectically imply one another."[33] Set within the surrounding architectural structure, *Step by Step* . . . derives its meaning not only from its impressive physical circumstance but also from its incorporation within the total framework of the museum. "Any object placed on exhibition in a museum space," Buren has written, "is framed not only physically by the museum architecture but also . . . by the cultural context which a museum signifies."[34]

Diverging from the work of LeWitt and Palermo, as from all prior art, on the essential question of context, Buren's work converges with functional reality and is not restricted to installation within traditional exhibition confines. Similar to the sails of *Sail/Canvas* . . . or the doors of *Watch the Doors Please*, the staircase of *Step by Step* . . . maintains its practical role while also functioning as art. As an actual juncture between the museum's lobby and its collections on the second floor, the work unites the separately defined art and non-art spheres. Performing as both staircase and sculpture, it acts as a liaison with the chronologically arranged galleries of European painting and sculpture that encompass works from medieval times to the 20th century. Through its fusion of sculptural form and architectural function, Buren's work defines the museum's main stairway—in all of its grandeur—as the institution's symbolic pedestal and core, elevating the museum visitor literally and figuratively into its "hallowed halls."

In contrast to all works in the Art Institute's collection to date, *Step by Step* . . . cannot be considered apart from its total context. Physically separated from the galleries where traditional works, generally severed from their original settings, are shown in historical sequence, *Step by Step* . . . interacts with the museum considered as an architectural and cultural whole. While other works are subject to multiple categorizations and relocations, Buren's work is solely contingent upon the existing reality with which it coincides.

NOTES

1. The use of this Latin term, referring to "situation," has been used freely in recent years to describe works done on site. Buren, possibly the first to adopt this phrase in relation to contemporary art, has used it in connection with his work since 1968.

2. Daniel Buren, "It Rains, It Snows, It Paints," *5 Texts*, exh. cat. (New York and London, 1973), p. 24.

3. Ibid., p. 25.

4. Buren, "Beware," *5 Texts* (note 2), p. 15.

5. Buren, quoted in Rudi Fuchs, ed., *Discordance/Coherence*, exh. cat. (Eindhoven, Holland, 1976), p. 4.

6. On this work and on the work of Buren in general, see B.H.D. Buchloh, "Formalism and historicity—changing concepts in American and European art since 1945," in The Art Institute of Chicago, *Europe in the Seventies: Aspects of Recent Art*, exh. org. by A. James Speyer and Anne Rorimer, 1977, pp. 99–103.

7. Fuchs (note 5), p. 5.

8. D. Buren, "Sail Art," *Voile/Toile, Toile/Voile*, exh. cat. (Berlin, 1975–76), not pag.

9. A guide accompanying the exhibition reproduced installation photographs of past exhibitions in order to illustrate where specific works had previously been placed.

10. D. Buren, "On Statuary," *Daniel Buren: around "Ponctuations"* (Lyons, 1980), not pag.

11. Fuchs (note 5), p. 61.

12. Concerning this work, see B.H.D. Buchloh, "The Museum and the Monument," *Les Couleurs: sculptures, Les Formes: peintures* (Halifax, Nova Scotia, and Paris, 1981), p. 20.

13. Articles devoted exclusively to this work include: Judith Russi Kirshner, "Chicago: 'Watch the Doors Please,' Illinois Central Gulf Railroad and the Art Institute of Chicago," *Artforum* 20 (Feb. 1982), pp. 90–91; and Paul Krainak, "Buren Stripes Ride the Rails in Chicago Installation," *New Art Examiner* 9 (Nov. 1981), p. 11.

14. Judy Munson, "Rail cars are artist's rolling canvas," *Suburban Trib* (Southwest Cook County, Ill.) (Dec. 29, 1980).

15. Compare Buren, "Critical Limits," *5 Texts* (note 2), p. 45.

16. Buren, "On the Autonomy of the Work of Art," *Daniel Buren: around "Ponctuations"* (note 10), not pag.

17. Buren, "On the Institutions of the Art System," *Daniel Buren: around "Ponctuations"* (note 10), not pag.

18. This work was conceived by Buren after he had proposed an early version of *Watch the Doors Please*, which, for practical reasons, was realized only later at the Art Institute as a special exhibition in itself.

19. Quoted in New York, The Metropolitan Museum of Art, *Frank Stella*, exh. cat. by William Rubin (1970), p. 60.

20. Quoted in Gregory Battcock, ed., *Minimal Art, A Critical Anthology* (New York, 1968), p. 157.

21. G. R. Swenson, "What is Pop Art?," in John Coplans, ed., *Roy Lichtenstein* (New York, 1972), p. 55.

22. Coplans, "Talking with Roy Lichtenstein," in Coplans (note 21), p. 86.

23. Robert Morris, "Notes on Sculpture, Part IV: Beyond Objects," *Artforum* 7 (Apr. 1969), p. 54.

24. David Bourdon, *Carl Andre, Sculpture 1959–1977* (New York, 1978), pp. 26 and 19, respectively.

25. Andre quoted in Bourdon (note 24), p. 27.

26. Quoted in New York, The Museum of Modern Art, *Sol LeWitt*, exh. cat. (1978), p. 53. With this title for his series of fluorescent "monuments," Flavin paid homage to the avant-garde Russian artist Vladimir Tatlin, whose proposed 1920 *Monument to the Third International* sought to unify painting, sculpture, and architecture.

27. Quoted in Bourdon (note 24), p. 28.

28. LeWitt quoted in New York, Museum of Modern Art (note 26), p. 139.

29. Bernice Rose, "Sol LeWitt and Drawing," in New York, Museum of Modern Art (note 26), p. 32.

30. LeWitt quoted in New York, Museum of Modern Art (note 26), p. 130.

31. See Anne Rorimer, "Blinky Palermo: Objects, 'Stoffbilder,' Wall Paintings," *Artforum* 17 (Nov. 1978), pp. 28–35.

32. D. Buren, "Notes on Work in Connection with the Place Where it is Installed, Taken between 1967 and 1975," *Studio International* 190 (Sept.-Oct. 1975), p. 125.

33. Ibid., p. 124.

34. D. Buren, "A Statement by the Artist," in Hartford, Wadsworth Atheneum, *Dominoes: A Museum Exhibition* (1977), not pag.

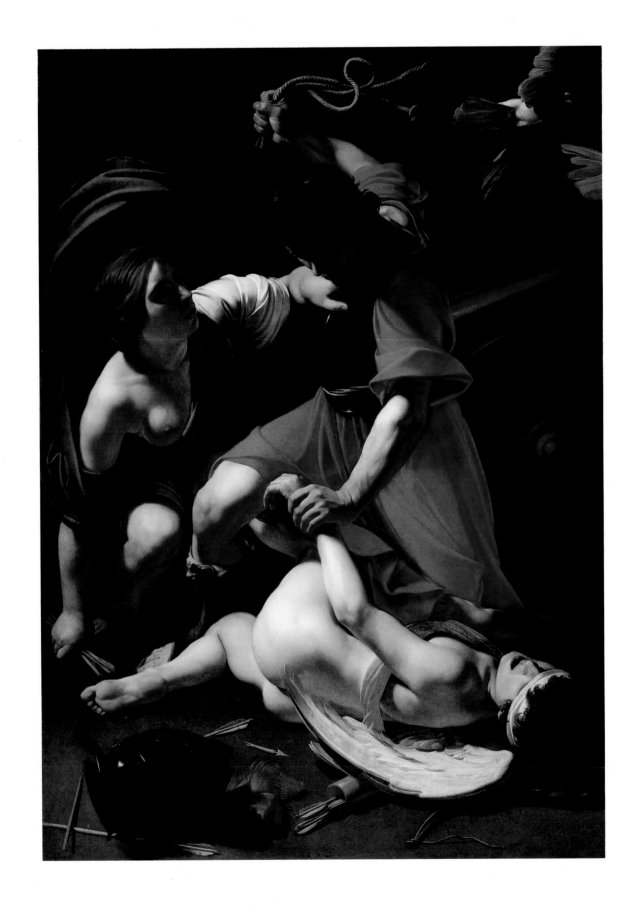

An Examination of Bartolomeo Manfredi's *Cupid Chastised*

ALFRED MOIR, *University of California, Santa Barbara*

*T*HE SOURCES OF our knowledge of painting in Rome during the early years of the 17th century are relatively numerous: several writers; a few legal documents; some contracts, inventories, and diaries; and the paintings themselves, particularly those that are signed or dated, or both. But these sources are fragmentary, so they turn the historian of art (like all historians) into a kind of detective, using whatever hard facts are available to provide the basis for what he hopes are informed and correct hypotheses. Sometimes, documents providing new information do turn up and, if the art historian has done his work well, they prove his hypotheses. Such is the case with the painting in The Art Institute of Chicago entitled *Cupid Chastised* (fig. 1) by the Italian painter Bartolomeo Manfredi (1580/87–1620/21).[1] If these new facts seem minor and peripheral in comparison to the quality and significance of the painting, their implications are nonetheless far-reaching.

Considering the scale and importance of the Chicago painting, remarkably little is known about it and its history; even the attribution to Manfredi has been questioned. The painting first appeared in art-historical liter-ature in 1937, when it was published as a newly found work by Caravaggio (1571–1610):[2] there is no date, signature, or inscription on the painting to indicate otherwise. Even though the great Caravaggio expert Roberto Longhi had already recognized and published it as by Manfredi in 1943,[3] it was acquired in 1947 for the Art Institute as a Caravaggio, and was included in the epochal Caravaggio exhibition in Milan in 1951 with an attribution to the "School of Caravaggio."[4] Soon after acquiring it, however, the Art Institute relabeled it with its current attribution to Manfredi. But, as recently as 1972, it was suggested that it is instead by an "unknown Nordic follower" of Caravaggio.[5]

Caravaggio's style exerted a strong influence on many painters in Rome during the first decade of the 17th century. They saw in his work a new, not to say a revolutionary, mode of painting, the antithesis of the elegantly artificial and often esoteric Mannerist style that had been predominant in the city during the second half of the 16th century. As fascinating as this style could be in the hands of such masters as Caravaggio's one-time employer, the Cavaliere d'Arpino, it had been reduced to tired formulas in the hands of lesser artists. The arrival in Rome of Caravaggio and his equally great contemporary Annibale Carracci (1560–1609) from their native cities in northern Italy during the 1590s reinvigorated painting in the papal city.

Though traditionally seen as antithetical to each other, in their different manners Caravaggio and Carracci both rejected Mannerism by reinstating nature as their primary

source of inspiration. Caravaggio's approach was the more upsetting: he refused to paint the enormous wall and ceiling fresco decorations that were the commissions most desired by contemporary artists (and, incidentally, where most of them learned their trade as apprentices) and instead limited his oeuvre to humanly scaled oil paintings. He was a master of staging who set up his compositions as if in spatial continuity with the real world outside the canvas and illuminated them theatrically with sharp contrasts between bright spots of intense light and deep, enveloping shadows. All of these features made his art seem sensational: outrageous to conservatives but almost irresistible to many sophisticated collectors and to numerous young artists.

However, Caravaggio was jealous of others who might imitate his style; he was ill-tempered and prepared to go to almost any extreme to protect it.[6] This defensiveness was the cause of a legal hearing involving Caravaggio in 1603. The painter and art historian Giovanni Baglione (c.1566–1643) had, during the first two or three years of the century, dared to paint some pictures that rivaled Caravaggio's, at least in Caravaggio's eyes. The artist apparently responded, with several of his friends, by writing and distributing some scurrilous and obscene verses about Baglione and his paintings.[7] The indignant victim went to court, accusing Caravaggio and his friends of libel. Caravaggio denied everything, although he was probably guilty, and he was eventually let off.

But Caravaggio had made his point, and it was not until after 1606, when he left Rome, that his imitators became very active. There was still a great demand for pictures like his, and a flourishing trade developed in copies and even deliberate fakes of his works. A number of artists, Manfredi among them, adopted his style, but modified it to form a personal variation of it.[8]

The confusion concerning the attribution of the Art Institute's painting is due, in part, to the fact that among such followers of Caravaggio, Manfredi is the least known, even though perhaps the closest. Most of our knowledge of his life is based on only two contemporary sources. The aforementioned Baglione, who must have known Manfredi, wrote a few words about him in his *Vite* of 1642; and Giulio Mancini (1558–1630), Manfredi's first biographer, between 1619 and 1621 compiled a manuscript entitled *Considerazioni sulla pittura* detailing his knowledge of contemporary Roman painting and painters.[9] Few extant documents refer to Manfredi's paintings, none providing us with exact dates, and the evolution of his style is entirely hypothetical.[10]

Manfredi was born in Ostiano, near Mantua, in southeastern Lombardy. Traditionally, his birthdate has been cited to be about 1580;[11] however, when Mancini wrote *Considerazioni*, he said that Manfredi was still living and

was 33 or 34 years old, which would indicate a birthdate of about 1587. Baglione implied that Manfredi died during the reign of Pope Paul V Borghese, whose death occurred in 1621.

Mancini went on to say that Manfredi was trained locally, in Cremona, Brescia, and Milan; and that then, while still very young, he moved to Rome, where he remained until his death. According to Baglione, he studied with Cristoforo Roncalli (called Il Pomarancio; 1552–1626), who was an important and well-connected artist in the capital.[12] Though the date of Manfredi's arrival in Rome is not certain, since Roncalli left the papal city in 1606, it must be presumed that Manfredi arrived well before then. Although there is no documented evidence of Caravaggio having used assistants or having trained any young painters, Manfredi may somehow have been associated with him.[13] In the records of the 1603 legal hearing brought about by Baglione, mention is made of Caravaggio having a servant named Bartolomeo.[14] If we accept the later birth date set forth for Manfredi by Mancini, then Manfredi would have been only 16 years old, too young to set himself up as an independent artist. At so young an age, an aspiring artist would have had to accept whatever opportunity came his way, even if it included sweeping floors; and the description of this Bartolomeo, who might have been Manfredi, as a servant would by no means preclude his eventually becoming a distinguished painter. It is, however, more likely that Manfredi, like Caravaggio's other imitators, did not study with him at all; whatever stylistic affinities he had with Caravaggio were developed after he left Roncalli and probably after 1606, when both Roncalli and Caravaggio had left Rome and Manfredi had established his independence.

Manfredi did not have any of the large-scale public church commissions that earned Caravaggio his first public success and enduring fame.[15] The majority of Manfredi's paintings, however, like Caravaggio's, were of religious subjects, but like his rare classical subjects, they were more genrelike in feeling than inspirational. Manfredi eventually had some powerful patrons, including the great Roman collector Marchese Vincenzo Giustiniani, a supporter of Caravaggio's who owned a *Saint Jerome* (now lost) and a large *Appearance of Christ to the Virgin* (fig. 2), both by Manfredi.[16] A number of paintings attributed to him can be found in inventories of royal or noble collections made during the decades after his death, but few of these works survive and fewer still are documented outside of the inventories.[17] Although, admittedly, we must be wary of these reports,[18] they provide at least some evidence of the degree to which Manfredi's works were valued.

The recent discovery of two 17th-century inventories

FIGURE 2 Manfredi, *Appearance of Christ to the Virgin*, c. 1610/20. Oil on canvas; 260 × 178 cm. Florence, Mina Gregori Collection. Photo: the author.

in the Vatican describing the Art Institute's painting is therefore of considerable significance, not only because they make it possible to trace more fully the picture's provenance, but also because they support the attribution of the work to Manfredi. *Cupid Chastised*, and therefore Manfredi's career, can now be reassessed in light of this new evidence.

The earlier of the two inventories was made in 1644 of the estate of Cavaliere Agostino Chigi of Siena. There is no mistaking the description of the picture:

A painting in a wood frame two-and-three-quarters *braccia* [arms] high and two *braccia* wide, representing a soldier Mars beating Cupid in the presence of Venus, who attempts to defend the boy, a work by Bartolomeo Manfredi Milanese, [valued at] 100 *scudi*.[19]

The inventory locates the painting in the ground-floor gallery of the famous hospital of Santa Maria della Scala, of which the cavaliere was rector from 1610 until his death.

The time span between Manfredi's death in 1620 or 1621 and this inventory, made more than twenty years later, might cast doubt on the attribution were it not strengthened by a hitherto puzzling reference by Mancini in his *Considerazioni*. In it, he mentioned a work of art belonging to the Cavaliere Chigi in Siena, saying that it was "perhaps the best thing that Manfredi had made."[20] Though he does not describe this work, it is reasonable to assume that he was speaking of the same painting and that it remained in Siena from the time of Mancini's reference until the cavaliere's death.

In 1657, a similar entry appears in a second inventory, this one of the Chigi possessions in Rome, where one branch of the family lived. In 1655, Fabio Chigi culminated his brilliant career as a Vatican diplomat with his election to the papacy as Alexander VII (reigned 1655–67). It is probable that the second inventory was made in order to distinguish the new pope's possessions, which would be inherited by the Church, from those of members of his family, which would remain in their hands. The description once again clearly identifies the subject of the Chicago painting:

. . . a painted picture of Mars beating Cupid and Venus who pretends to restrain him . . . [illegible] approximately seven *palmi* [palms] high by approximately five-and-a-half *palmi* wide by Bartolomeo Manfredi, with a smooth gold frame.[21]

Not until the late 18th century is there any other record of this painting. Lady Anne Miller, an aristocratic English traveler, wrote in 1776 of having seen in the Palazzo Chigi in Rome a painting of Mars whipping Cupid in the presence of Venus. While she stated that this picture was by Caravaggio, it is probable that she was referring to the Chicago painting.[22] We can be reasonably sure that the Chigi family retained possession of the painting until early in this century. The late Marchese Giovanni Incisa della Rocchetta, a distinguished historian who was himself a member of the Chigi family, recalled the painting being in the Palazzo Chigi when he lived there as a boy.[23] After the palace was acquired by the Italian government in 1917, the painting, along with other possessions not sold at auction, was apparently moved to another of the Chigi residences and relegated to an attic. The neglected collection was frequently "raided" by dealers and sold off. In some way or another, the painting found its way into the possession of Armando Brasini, a collector/

FIGURE 3 Manfredi, *Crown of Thorns*, c. 1605/10. Oil on canvas; 118 × 135 cm. Munich, Staatsgemäldesammlungen.

dealer to whom it belonged when it was first published in 1937 and from whom it was sold to the Art Institute by Wildenstein and Company ten years later.

While the provenance of *Cupid Chastised* alone would not be conclusive enough to establish that the painting is by Manfredi, it is clearly in his youthful manner. A small group of paintings attributed to Manfredi, probably some of his earliest, can be associated with the Chicago picture, specifically a *Martyrdom of Saint Bartholomew* (Milan, private collection), a *Crown of Thorns* (fig. 3), and *The Four Seasons* (fig. 4).[24] In all three paintings, the figures are big and even clumsy, with expressionless oval faces and smooth-textured draperies in tight, linear folds; they recall the work of about 1600 of his teacher Roncalli (see fig. 5). Reminiscent, too, of Roncalli's influence is the bright blue sash of Cupid in the Chicago painting.

On the other hand, the painting is primarily based on Caravaggio's style. The complex, wheellike composition is clearly derived from Caravaggio's *Crucifixion of Saint Peter* of 1600–01 (fig. 6). Also Caravaggesque are the strong chiaroscuro, warm colors, and choice of an instant of dramatic, violent action that seems suddenly frozen. Like Caravaggio, Manfredi set his models in a shallow interior space against a dark background that creeps around and over them like a heavy fog, and illuminated them with a beam that cuts through the shadows like a searchlight. Manfredi's use of chiaroscuro, however, varies somewhat from that of Caravaggio. In the Chicago composition, the bright light that defines the figures illuminates the entire foreground yet leaves some crucial areas, such as Mars's face, in shadow. The painting is a little clearer and more evenly lit than Caravaggio's mature works, where the figures are often obscured by a pervasive, mysterious darkness.

In *Cupid Chastised*, an indignant Mars, god of war (who may have been Cupid's father), beats Cupid, whose mother, Venus, goddess of love, attempts to intervene. Cupid's helmet and broken arrows lie on the ground while doves fly off at the upper right. Mars had good reason to be angry: Not only had his illicit affair with Venus, brought on by the mischief of love, exposed him to the derision of other gods and the outrage of Venus's lawful husband, the god Vulcan, but it also distracted him from his proper business of driving his war chariot to military victory and glory. The symbolic meaning underlying the action—that love and war are enemies, that love is helpless in the face of war, and that confronted by war's wrath the doves of peace and love fly away (literally as well as figuratively)—can be recognized as a kind of pessimistic answer to Caravaggio's related composition, *Victorious Love* (fig. 7), where love triumphs over the symbols not only of war but of government, the intellect,

FIGURE 4 After Manfredi, *The Four Seasons*, n. d. Oil on canvas; 134.5 × 91.5 cm. Dayton, Ohio, Art Institute, Gift of Mr. and Mrs. Elton F. MacDonald.

FIGURE 5 Cristoforo Roncalli, called Il Pomarancio (Italian, 1552-1626), *Saint Domitilla Between Saints Nereus and Achilleus*, c. 1596. Oil on canvas. Rome, Chiesa dei Santi Nereo e Achilleo. Photo: University Art Museum, University of California, Santa Barbara.

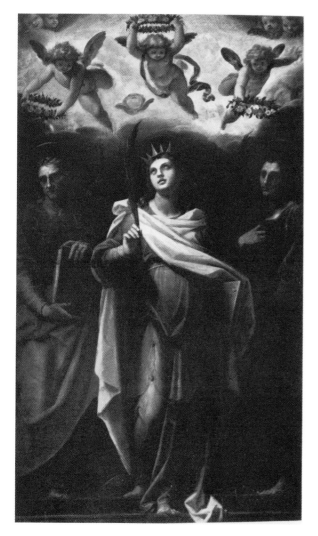

FIGURE 6 Michelangelo Merisi da Caravaggio (Italian, 1571-1610), *Crucifixion of Saint Peter*, 1600-01. Oil on canvas; 230 × 175 cm. Rome, Santa Maria del Popolo, Cerasi Chapel. Photo: Gabinetto Fotografico Nazionale, Rome.

Above left
FIGURE 7 Caravaggio, *Victorious Love*,
c. 1601/03. Oil on canvas; 154 × 110 cm. Berlin-
Dahlem, Staatliche Museen. Photo: the author.

Above right
FIGURE 8 Circle of Palma Giovane (Italian,
1544-1628), *Cupid Chastised by Mars*, c. 1600.
Pen and ink. Copenhagen, Royal Museum, inv.
no. Mag. IX, p. 7.

Facing page left
FIGURE 9 Giovanni Baglione (Italian,
c.1571-1644), *Divine Love Conquering Profane
Love*, c. 1603. Oil on canvas; 179 × 118 cm.
Berlin-Dahlem, Staatliche Museen.

Facing pace right
FIGURE 10 Manfredi, *Bacchus and a Drinker*,
c. 1610/15. Oil on canvas; 132 × 96 cm. Rome,
Galleria Nazionale d'Arte Antica. Photo:
Alinari.

and even fame—indeed, by implication, over all but the visual arts.[25]

The idea of love has inspired art throughout the ages. Only since the Renaissance and the increasing secularization of art, however, has this theme come to the position of preeminence that it now occupies as the subject of literature and the visual arts. The majority of images relating to love refer not to its joys and successes but to its problems. The faithless lover, unrequited love, misalliances, parental opposition, youthful rebelliousness, and love's anguish—this is the stuff of which literature, music, and art have traditionally been made.

Often, love is portrayed as a little villain, personified as Cupid or Eros, whose thoughtless mischief demands punishment. The theme of the punishment of love was not new to Manfredi's time. At Pompeii, for example, in a fresco once in the Casa dell'Amore Punito and now in the Museo Nazionale at Naples, Venus deprives Cupid of his quiver of arrows and rebukes him, causing him to hang his head in what we can assume to be momentary contrition. Similar punishments appear in other works of art: Cupid's wings are clipped or his arrows broken or taken away; betrayed women beat him or tie him blindfolded to a stake to burn as he has made them do. Probably most

162

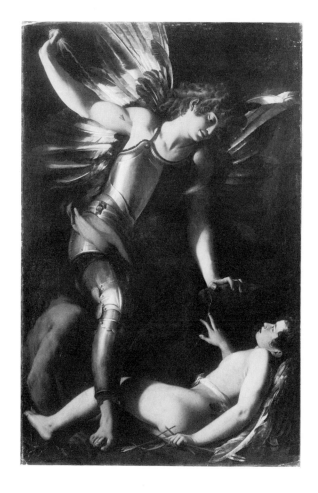

closely resembling the Art Institute painting is a drawing (fig. 8) from the circle of the Venetian Palma Giovane.[26] Mars is seated with his back to the viewer and the boy Cupid is spread-eagled between the two adults, but otherwise the poses and the compact grouping of the figures are similar enough to suggest some specific relation to the painting. Manfredi, like Caravaggio before him, was certainly familiar with this long tradition of similar images.[27]

It is possible that Manfredi derived the composition of the Chicago painting from one by Caravaggio of a similar subject. Baglione reported that Caravaggio painted a *Divine Love Conquering Profane Love* for Cardinal Francesco Maria del Monte, his first major patron. However, no such painting is listed in the posthumous inventory made in 1627 of the cardinal's collection: he may have sold or given away the painting. Or, conceivably, Baglione was mistaken and Caravaggio never painted it. However, Baglione would have had good reason to remember it: he painted two versions of the same subject (see fig. 9), the second of which was mentioned in the 1603 hearing involving Caravaggio (presumably one of the offending imitations Caravaggio objected to). If, then, Caravaggio did paint a *Divine Love*, reminiscences of that painting may appear in Baglione's two compositions

and in the Chicago canvas. The figures of Divine Love and Mars are similarly posed, although Manfredi's Mars is reversed from that of Baglione's Divine Love and is more violent, and there are some resemblances between the two naked boys and in their relation to their attackers.[28]

Manfredi painted only two classical subjects that we know of—the Chicago painting and the *Bacchus and a Drinker* (fig. 10).[29] This neglect of classical subject matter sets Manfredi, along with Caravaggio, apart from most of their contemporaries, for whom such themes were very important, being the principal alternative to religious subjects. Furthermore, Caravaggio and Manfredi seem to have shared a very different attitude toward their few classical paintings.

Throughout the 16th and 17th centuries—indeed, for many centuries before that—humanistic learning consisted mainly of the study of ancient literature, primarily Latin but also Greek, and classical mythology. Whether in the Netherlands or in the Mediterranean world, classical mythology and its symbolic meanings, both in literature and in the visual arts, were understandable to all educated people. Because this mythology spoke metaphorically of fundamental, common themes—virtues and vices, emotions, philosophy, social conditions, personal

FIGURE 11 Manfredi, *Musical*, c. 1615. Oil on canvas; 130 × 189 cm. Florence, Galleria degli Uffizi. Photo: Gabinetto Fotografico Nazionale, Rome.

relationships, institutions, and cities and states, all of which were personified with appropriate attributes—it was usually treated with a sobriety approaching pedantry.

Such gravity, however, was not characteristic of either Caravaggio's or Manfredi's approach. In his *Victorious Love* and his *Bacchus*, Caravaggio brought the ancient gods down from Olympus into contemporary bohemia, and Manfredi followed him. Their attitude toward their iconography was iconoclastic; they may have presented erudite themes, but they poked fun at the pretentiousness of classical learning even while indulging in it. So, we can look at *Cupid Chastised* and see it as mock heroic. Despite Venus's billowing drapery and Cupid's wings, what Manfredi represented is not an idealized visualization of the age-old struggle between love and war, but a genre scene—a domestic scuffle of the sort that can still be seen and heard in Trastevere and Testaccio and other densely populated sections of Rome, or any other city for that matter.

All of Manfredi's later paintings, such as the *Musical* (fig. 11), tend to be friezelike, as if he had excerpted the group of figures seated with the saint around the table from Caravaggio's great *Calling of Saint Matthew* (fig. 12) and compressed them into a shallower, more compact space. The explosive, centrifugal composition of the Art Institute's painting—where not only the doves but almost everything in the picture seems to burst out from the center of Mars's left hand grasping Cupid's left wrist—was superceded by a centripetal design that draws attention from the periphery of the picture toward the focal point. The pronounced verticals and horizontals underlying this mature design form a rectilinear compositional structure that further stabilizes the whole image. How-

ever, unlike Caravaggio's *Saint Matthew* group, where action seems to be suspended only momentarily, the gestures and movements of Manfredi's figures appear to be frozen immutably into place.

Although Caravaggio and Manfredi paid lip service to traditional humanistic learning in their classical subjects, and Manfredi's religious subjects reflected a similar attitude, the iconoclastic "realism" of their pictures upset most contemporary art critics and conservative painters, who thought them vulgar and indecorous. But such pictures were appealing to many others—to enlightened collectors like the Marchese Giustiniani and to the many young painters who came to Rome and fell under the spell of Caravaggio's oeuvre.[30] Most of these artists were French or Netherlandish, although some Italians responded as well. And although they had no direct contact with Caravaggio after he left the city in 1606, they could at least study his paintings in Rome, which was, and still is, rich in his works; and other Caravaggesque painters like Manfredi, Carlo Saraceni, and Orazio Gentileschi served as his surrogates.[31]

If Manfredi himself had any formal relation with some of these painters, we have no documentary evidence of it. But his art did exert great influence and his paintings were much-copied: so many canvases were attributed to him in so many different collections that, clearly, his works were admired and in demand. The existence of many copies of his paintings, too, admit to his popularity, for if his pictures had not been sought after, copyists would not have bothered with them.[32] His imitators, in fact, were so numerous that the German painter and art historian Joachim von Sandrart (1606–1688), who arrived in Rome about 1629 and also became a protégé of the Marchese

FIGURE 12 Caravaggio, *Calling of Saint Matthew*, 1559–1600. Oil on canvas; 338 × 348 cm. Rome, San Luigi de' Francesi, Contarelli Chapel. Photo: Gabinetto Fotografico Nazionale, Rome.

Giustiniani, credited Manfredi with creating his own, distinctive style of painting, which the German called the "Manfredi manner." These followers of Manfredi—second-generation Caravaggisti—included, among others, three important painters: Valentin du Boullogne (1591–1632), Nicolas Regnier (c.1590–1667), and Gerard Seghers (1591–1651).[33] Seghers arrived in Rome in 1611 and Valentin and Regnier in 1612. A fourth painter, Nicolas Tournier (1590–c.1660), although not mentioned by Sandrart, seems to have been closest to Manfredi, although he did not arrive in Rome until 1619. Many of the copies of Manfredi's paintings are attributed to him, which suggests that he may actually have been employed in the older painter's studio.

Indebted as he was to Caravaggio, Manfredi could not help putting his own imprint on his pictures. His private clientele, as well as the smaller scale and characteristic horizontal compositional format of his mature paintings, were distinctively his rather than Caravaggio's. Furthermore, in a great cosmopolitan center like Rome, fashions changed rapidly. With them changed also the expectations of patrons, to whom artists without Caravaggio's overriding genius had necessarily to pay close attention. By adapting the master's style not only to their own personalities but also to these changing expectations, Manfredi and the others of Caravaggio's closest followers provided means for the perpetuation of his achievements, altered but still viable.[34]

Although the Art Institute's *Cupid Chastised* does not appear to have had much, if any, direct influence on the practitioners of the "Manfredi manner," it is fundamental to the understanding of both Manfredi's career and his stylistic evolution. It thus provides a key to comprehend-ing the evolution of the entire Caravaggesque movement. It permits us insight into how young painters beginning their careers in Rome responded to what they found of interest there, most compellingly in Caravaggio's oeuvre, but also in the work of other masters, both present and past, and to such other influences as the taste of the leading patrons. We can now be more certain, because of the Chigi inventories, that *Cupid Chastised* is in fact by Manfredi himself; and that, thanks to Mancini's favorable reference to it, it was considered in its own time, as now, to be an admirable picture.

NOTES

1. The most recent detailed studies of this picture are in The Cleveland Museum of Art, *Caravaggio and His Followers*, exh. cat. by Richard Spear (1971), no. 44, pp. 128–30; and in this year's Caravaggio exhibition at The Metropolitan Museum of Art: see New York, The Metropolitan Museum of Art, *The Age of Caravaggio*, exh. cat. (1985), pp. 161–63.

2. Ettore Sestieri, "Un Caravaggio di più," *L'Arte*, n.s. 9 (1937), pp. 264–83. At that time, the painting was in the Brasini collection in Rome.

3. Roberto Longhi, "Ultimi studi sul Caravaggio e la sua cerchia," *Proporzioni* 1 (1943), p. 25.

4. See Milan, Palazzo Reale, *Mostra del Caravaggio e dei Caravaggeschi*, exh. cat. by Roberto Longhi et al. (1951), no. 62, p. 42.

5. Evelina Borea, "Considerazioni sulla mostra 'Caravaggio e i suoi seguaci' a Cleveland," *Bollettino d'Arte*, ser. 5, 57 (1972), p. 161.

6. During the years 1600–06, he is cited no fewer than 13 times in Roman police records, mostly for minor offenses, but finally, in July 1606, for a murder he had committed: see Alfred Moir, *Caravaggio* (New York, 1982), pp. 59–62, for a chronological list of these citations.

7. See Walter Friedlaender, *Caravaggio Studies* (Princeton, N.J., 1955), pp. 270–79 (expurgated in the English translation).

8. For a detailed analysis of this process, see A. Moir, *The Italian Followers of Caravaggio*, 2 vols. (Cambridge, Mass.,

1967), vol. 1, particularly pp. 15–21; idem, *Caravaggio and his Copyists* (New York, 1976), chaps. 1, 4, 6; and The Cleveland Museum of Art (note 1), pp. 22–38. On the demand for Caravaggesque pictures, see Margot Cutter, "Caravaggio in the Seventeenth Century," *Marsyas* 1 (1941), pp. 89–115.

9. Giovanni Baglione, *Le vite de' pittori, scultori et architetti* (Rome, 1642), p. 159. Mancini was physician (*archiatra*) to Pope Paul V (reigned 1605–21), but was also an art collector and dealer. Mancini's manuscript was not published, however, until 1956–57: *Considerazioni sulla pittura*, 2 vols., *Fonti e Documenti per la Storia dell'Arte* 1, ed. A. Marucchi, notes by Luigi Salerno (Rome, 1956–57); see specifically vol. 1, p. 251; vol. 2, p. 151 nn. 1093–99.

10. For the most recently compiled corpus of Manfredi's paintings, see Benedict Nicolson, *The International Caravaggesque Movement* (London, 1979), pp. 70–73. For an attempt to establish his chronology, see Moir, *Italian Followers* (note 8), vol. 1, pp. 39–43, 85–89. It has been updated but not basically changed by the following: B. Nicolson, "Bartolommeo Manfredi," *Studies in Renaissance and Baroque Art Presented to Anthony Blunt* (London, 1967), pp. 108–12; Florence, Palazzo Pitti, *Caravaggio e Caravaggeschi nelle gallerie di Firenze*, exh. cat. ed. by Evelina Borea (1970), pp. 14–22; Luigi Salerno, "A Painting by Manfredi from the Giustiniani Collection," *The Burlington Magazine* 116 (Oct. 1974), p. 616 (Salerno's dating of the Chicago painting contradicts that of Moir and Nicolson); Arnauld Brejon, "New Paintings by Bartolomeo Manfredi," *The Burlington Magazine* 121 (May 1979), pp. 305–10; and Jean Pierre Cuzin, "Manfredi's *Fortune-Teller* and Some of the Problems of Manfrediana Methodus," *Bulletin of the Detroit Institute of Arts* 58, 1 (1980), pp. 15–25.

11. See Milan, Palazzo Reale (note 4), p. 76.

12. For the most recent treatment of Roncalli, see Florence, Gabinetto dei Disegni e delle Stampe degli Uffizi, *Disegni dei Toscani a Roma (1580–1620)*, exh. cat. by W. Chandler Kirwin (1979), pp. 19–54.

13. In his youth, however, Caravaggio may have collaborated with his friend Mario Minniti, who, when they met again in Syracuse in southern Sicily in 1608, may have lent the master some assistance with the great *Burial of Saint Lucy* in the church of Santa Lucia there: see Moir, *Italian Followers* (note 8), vol. 1, pp. 183, 185–87; idem, *Copyists* (note 8), pp. 133–34 n. 223; Silvino Borla, "L'arrivo del Caravaggio a Roma," *Emporium* 135 (1962), pp. 13–16; and Howard Hibbard, *Caravaggio* (New York, 1983), p. 239. A suggestion has been made that later, in 1608–09, another Caravaggesque painter, Alonzo Rodriquez (1578–1648), may have helped Caravaggio with his *Resurrection of Lazarus*, now in the Museo Nazionale in Messina but originally painted for the church of the Crociferi in the same city: see Giovanni Urbani, "Schede di restauro," *Bollettino dell'Istituto Centrale del Restauro* 5–6 (1951), pp. 78–91; and Moir, *Italian Followers* (note 8), vol. 1, p. 183 n. 6.

14. The account of the legal hearing was included in an abridged version with an English translation by Friedlaender (note 7); the complete text was published in Italian by Gian Alberto dell'Ac-qua and Mia Cinotti, *Il Caravaggio e le sue grandi opere da San Luigi dei Francesi* (Milan, 1971), pp. 153–57.

15. According to Mancini (note 9), vol. 1, p. 251, the artist had begun to obtain some church commissions at the time of his death, but none has been identified.

16. See Salerno (note 10), p. 616.

17. According to Mancini (note 9), vol. 1, p. 251, the Grand Duke of Tuscany bought several works by Manfredi for high prices. There are five works (and two copies) at present in Florentine museums: see Florence, Palazzo Pitti (note 10), nos. 7–13, pp. 16–27. Other paintings now lost include those reported in the collections of Cardinal Verospi (c. 1620), the Patrizi family (1624), Cardinal Alessandro d'Este (1624), and the Ludovisi (1633) and Pignatelli (1647) families. Also lost are works mentioned in inventories of Gaston d'Orléans (1630), the Duke of Buckingham (1635), the Duke of Savoy in Turin (1635), King Charles I of England (1639), the Duke of Modena (1657), the Archduke Leopold (1659), and Cardinal Mazarin (1661). See Nicolson, "Bartolommeo Manfredi" (note 10), for an attempt to trace Manfredi's lost works.

18. For example, the paintings in the d'Este collection were apparently not by Manfredi at all but by his imitator, the French painter Nicolas Tournier (1590–c. 1660); at least the two paintings now in the d'Este collection in Modena are universally considered to be by Tournier, perhaps copies after lost originals by Manfredi: see Moir, *Italian Followers* (note 8), vol. 1, p. 86 n. 56. If it were not for Mancini's reference, the attribution of the Chicago painting to Manfredi in the two Chigi inventories discussed in this article would also be suspect.

19. "Un quadro con cornici di noce di alto braccia due 3/4 large braccia due rappresenta un soldato [Mars] che spezza [Amour] presente Venere, la quale cerca difenderlo, opera di Bartolomeo Manfredi Milanese scudi cento 100." See Archivio Chigi Armadio CCCLI (1644), in the Vatican.

For more information about the Chigi family, see Gaetano Moroni, *Dizionario dell'erudizione Storico-ecclesiastico da San Pietro sino a nostri giorni*, 109 vols. (1840–49), vol. 13 (Venice, 1842), pp. 79–80.

20. See Mancini (note 9), vol. 1, p. 251: "In Siena vi è uno (dis?)egnio [illegible] in casa del signor cavalier Chigi, la meglior cosa che forse [Manfredi] habbia fatta con intentione, fine, et verita." Salerno (in Mancini [note 9], vol. 2, n. 1098) suggests the illegible word might be *sdegno*, a struggle, which does indeed describe the painting.

21. "Un quadro dipinto di un Marte che spezza Amore e Venere che finge tenerlo [illegible] con strata alto p[a]lmi 7 incirca largo 5½ incirca di Bartolomeo Manfredi con cornice dorata liscia." See Archivio Chigi Armadio CCCLXXXI (1657), in the Vatican. There is some discrepancy between these measurements (seven by five-and-one-half palms = 156 × 122.87 cm) and those of the Chicago painting (175.3 × 130.6 cm), but makers of inventories in the 17th century were not very precise in taking dimensions (works were often measured as they hung in their frames on the wall, and the vertical height was usually farther

off), so the difference is probably not significant.

22. Cited in The Cleveland Museum of Art (note 1), p. 128.

23. Conversation between the Marchese Incisa della Rocchetta and the author in the spring of 1970.

24. The authorship of the *Crown of Thorns* has been disputed. Leonard Slatkes published it as by David de Haen in his monograph on Dirck van Baburen (Utrecht, 1965), p. 63, no. 33. Nicolson (*The International Caravaggesque Movement* [note 10], pp. 70–71) agreed with this author that it is an early work by Manfredi. The Dayton painting is a good, if over-restored, copy of the original *Four Seasons* that was formerly in the collection of Feodor Chaliapin, Paris. It is probably by a very capable northern European.

25. This is one of Caravaggio's few classical works. It was done for the Marchese Giustiniani and was described by Joachim von Sandrart, *Teutsche Akademie der elden Bau-, Bild-, und Mahlerei-Künste* (Nuremberg, 1675); trans. in Hibbard (note 13), pp. 375–80. According to Sandrart, the composition was displayed with 120 other paintings in the Giustiniani collection but kept behind dark green silk curtains lest it outclass all the others by comparison. See Robert Enggass, "L'Amore·Giustiniani del Caravaggio," *Palatino* 9 (1967), pp. 13–20, for an interpretation of the meaning of Caravaggio's painting; and Moir (note 6), p. 112, for a suggestion about the relation in it between the theme of love and the visual arts.

26. Also close in composition to the Art Institute painting is a bas-relief by Michelangelo's teacher, Giovanni Bertoldo (1420?–1491), in the Palazzo Scala, Florence. At the right, a nude, helmeted man (not Mars, but Negotium), posed like Manfredi's Mars, but in reverse, beats a cringing baby Cupid; an aged crone, who has not been positively identified but is perhaps a Maenad, takes Venus's role but no more effectively. See Alessandro Parronchi, "The Language of Humanism and the Language of Sculpture," *Journal of the Warburg and Courtauld Institutes* 27 (1964), pp. 115–16, pl. 22. The poses of both Bertoldo's Negòtium and Manfredi's Mars appear to be derived from the famous ancient relief of *Hercules and the Hydra* in the Vatican; whether Manfredi borrowed the pose from Bertoldo or directly from the Vatican relief is impossible to establish with certainty, although the latter possibility seems more likely, particularly because Bertoldo reversed Hercules's pose (as did Baglione for his *Divine Love*) and Manfredi did not.

27. See Mario Praz, *Studies in Seventeenth Century Imagery* (London, 1939), vol. 1.

28. Another *Divine and Profane Love*, attributed to the Pisan Orazio Riminaldi (1586–1631), who was in Rome between 1610 and 1626/27, may also have been related; see Moir, *Italian Followers* (note 8), vol. 1, p. 220 n. 40; vol. 2, fig. 286.

29. A third painting, a large canvas representing the *Contest of Apollo and Marsyas*, was listed in the inventory of the Barberini

collection, Rome, in 1686, but it is now lost. *Bacchus and a Drinker* belonged in 1749 to Cardinal Valenti Gonzaga, and may well have been in an ancestor's collection during the 17th century, the Gonzagas (who ruled Mantua) having been indefatigable collectors. See Moir, *Italian Followers* (note 8), vol. 1, p. 86 n. 55; vol. 2, fig. 101.

30. Among these young painters was probably Cecco del Caravaggio, one of whose masterworks, the *Resurrection of Christ*, (c. 1610), is also in the Art Institute (Charles H. and Mary F. S. Worcester Collection [1934.390]). Scarcely more than a name, Cecco is a mysterious figure with whom a handful of paintings have been linked. The subjects of a few of his works, and the somewhat forced composition of his *Resurrection*, suggest that he was aware of Manfredi and his oeuvre, although apparently not an intimate.

31. The Venetian Carlo Saraceni (1579–1620) had a regular studio with several apprentices and assistants (see Anna Ottani Cavina, *Carlo Saraceni* [Milan, 1968]); the Tuscan Orazio Gentileschi (1563–1639) is documented as having employed assistants and having trained both his daughter Artemisia and a son (see R. Ward Bissell, *Orazio Gentileschi* [University Park, Penn., and London, 1981]); a third, the Roman Orazio Borgianni (1578–1616) is not known to have had any assistants or students, though this is unlikely (see Harold Wethey, "Orazio Borgianni," *Dizionario biografico italiano* [1970], vol. 12, pp. 744–47).

32. The most comprehensive list of copies after Manfredi is in Nicolson, *The International Caravaggesque Movement* (note 10), pp. 70–73.

33. To these three should perhaps be added Gerard van Honthorst (1590–1656), a native of Utrecht who was in Rome from 1610 to 1620. But he was more a contemporary of Manfredi's than a successor, and his influence as a first-generation surrogate for Caravaggio was as great as Manfredi's and was independent of him. The most comprehensive treatment of these second-generation followers of Caravaggio is in Nicolson, *The International Caravaggesque Movement* (note 10), *passim*, although it is in outline form and therefore skeletal, and was not edited by the author before his death.

34. Among the preeminent masters of seventeenth-century painting, only Georges de La Tour (1593–1652) gave primary allegiance to Caravaggesque painting and maintained this commitment throughout his career. The similarity between some of his paintings and Manfredi's, both in format and in the attitudes they display toward their subject matter, is striking, although no direct contact between La Tour and Manfredi or any of his paintings is known. Other northern Europeans, such as Dirck van Baburen (c. 1594/95–1624) of Utrecht, Theodor Rombouts (1597–1637) of Antwerp, and the unidentified painter known as the Master of the Judgment of Solomon, appear as obviously indebted to Manfredi.